IMAGES
of America

STENNIS
SPACE CENTER

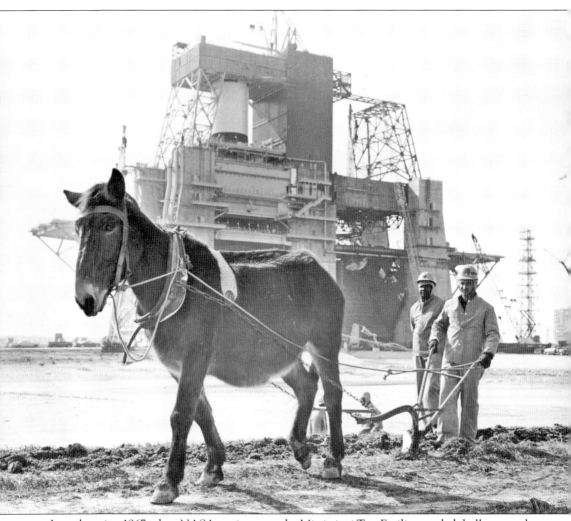

In early spring 1967, when NASA engineers at the Mississippi Test Facility needed shallow trenches dug to protect electrical cables, they employed mule power and a one-bottom plow to render the straightest furrows for those cables. In the background is the dual-position B-1/B-2 Test Stand used to static test fire the "workhorse" of America's space hardware, the Saturn V S-IC rocket booster. (Author's collection.)

ON THE COVER: An Apollo/Saturn V second stage (S-II) is hoisted from its transport barge onto the A-2 Test Stand at the Mississippi Test Facility on February 21, 1967, for static firing. Manufactured by North American Rockwell Inc., the S-II was 81.5 feet in length and 33 feet in diameter; its five J-2 engines provided 1,150,000 pounds of thrust. (Author's collection.)

IMAGES
of America

STENNIS
SPACE CENTER

Cindy Donze Manto
Foreword by Fred W. Haise Jr.,
Apollo astronaut

ARCADIA
PUBLISHING

Published by Arcadia Publishing
Charleston, South Carolina

Printed in the United States of America

Library of Congress Control Number: 2017959250

For all general information, please contact Arcadia Publishing:
Telephone 843-853-2070
Fax 843-853-0044
E-mail sales@arcadiapublishing.com
For customer service and orders:
Toll-Free 1-888-313-2665

Visit us on the Internet at www.arcadiapublishing.com

*To my husband, Fulvio Manto, an aerospace engineer who immigrated
from Italy and began his career at Michoud Assembly Facility.*

CONTENTS

FOREWORD

The current John C. Stennis Space Center came into being in October 1961 as the Mississippi Test Facility (MTF). At that time, I had been working as a NASA research pilot at the Lewis Research Center in Cleveland, Ohio. Whereas the MTF was created for the purpose of testing and certifying powerful rocket engines, Lewis Research Center had for years been working on reciprocating and jet engines for aircraft.

Testing the large, very loud rocket engines required a lot of acreage to assure mitigating the noise for the protection of surrounding communities. This required several small cities to be closed down with the relocation of their citizens. The primary Stennis site encompasses some 125,000 acres with a larger Buffer Zone established beyond around the compass.

The first major task was to prepare the Apollo program engines, including multiengine stages, for the huge Saturn V launch vehicle. Each Saturn V rocket included 11 engines: five F-1s on the first stage, five S-2s on the third stage, and one S-2 on the third stage. This rocket propelled nine missions to the Moon, including the Apollo 13 mission that I flew; hence, the expression "If you want to go to the Moon, you will go through Mississippi."

This same service was provided in the preparation and certification of the SSME engines for the 135-flight Space Shuttle program. And that work continues today with similar rocket-engine testing supporting the soon-to-be-flown NASA Space Launch System.

After the last test of an Apollo engine at MTF, I was assigned to join Senator Stennis and other NASA officials at an auditorium setting to thank the workers who had performed those incredible tasks . . . only to be laid off with the end of the program. I joined Senator Stennis in a following meeting with high-level representatives from several government agencies. Senator Stennis along with MTF's director, Jackson Balch Sr., described the facility as a "national asset" and encouraged them to utilize it for future program considerations. From that has grown the current NASA Stennis Space Center with several dozen government operations. Even a foreign operation, as Rolls Royce now conducts all their large-jet-engine testing and certification at Stennis. They like to say that "NASA can make lots of noise, but we do it a lot longer."

I have a second home in Mississippi and come over at least once a month. When I am out at the grocery store or in the shopping mall, I often ask people in passing what they know about Stennis activity. I am continually amazed that all most know is that NASA tests rocket engines there. Local news telling of recent rocket firings keeps them up with that activity. They are not aware of the US Navy presence with more oceanographers at work than anywhere in the country. Or the National Oceanic and Atmospheric Administration's work with weather buoys and the tsunami buoy network off Japan to guard the West Coast of the United States. Just completely unaware of the broad scope of technology with supporting workers that is in their backyard . . . a breadth of activity that exceeds what you would find in one place anywhere else in the United States. Hopefully, those who read this book will come to understand Stennis: truly a national asset.

—Fred W. Haise, Apollo 13 Lunar Module Pilot

Acknowledgments

Special thanks to Margaret Stennis Womble; Fred W. Haise Jr., Apollo astronaut; John Wilson, executive director, and Betsy Bethea, executive assistant, both of INFINITY Science Center Inc.; the Kemper County Historical Association; Heather Moore of the US Senate Historical Office; Valerie Buckingham of the NASA Office of Communications, and Paul Foerman, public information officer, both of Stennis Space Center; Charles Gray, executive director, Max Gray, and William E. Coleman, editor of *The Historian of Hancock County*, all of the Hancock County Historical Society.

Many thanks to Leah Rials of the McCain Library and Archives, the University of Southern Mississippi, Hattiesburg; Ryan P. Semmes, associate professor and archivist, and Amanda Carlock, library associate, both of the Mitchell Memorial Library, Mississippi State University, Starkville; Mike Jetzer, friend and authority on all matters related to space, space travel, and the creator of heroicrelics.org; Don H. Thompson, author of *Stennis, Plowing a Straight Furrow*; Fulvio Manto, retired director of mechanical and propulsion design, Lockheed Martin Space Systems Company; Kenneth J. Donze, for his expertise in automobiles; Allison Anderson, unabridged Architecture, Bay St. Louis; and Laurin Stennis.

Please note that this is not an official publication of NASA and that any opinions expressed or errors in content are the responsibility of the author.

INTRODUCTION

At one point during the rise in the number of NASA field installations that were being built or refurbished to meet the challenges of space travel, NASA's first administrator, James Webb, commented that "The road to the Moon will be paved by bricks, and steel, and concrete here on Earth." During an era of perceived scientific superiority over other nations, facility mobilization resembled that of a mobilization for war: a Cold War of wit and intellect.

Planning for Mississippi Test Operations (MTO) originally included both the Saturn V first stage and the Nova rocket. The 363-foot-tall Nova, direct ascent (Earth to Moon) rocket, dwarfed the Saturn V three-stage launch vehicle. Testing both could not be done at existing sites at Marshall Space Flight Center in Huntsville, Alabama, because of the relatively large population surrounding Redstone Arsenal that would be subject to the dangers of the explosive fuels and noise levels.

A new facility capable of captive test firing large space vehicles in a relatively isolated location, with water access and year-round mild weather, was found on the Pearl River in the southwest corner of Mississippi. The location was approximately 38 canal miles northeast of the immense, government-owned Michoud Assembly Facility, which could accommodate the colossal dimensions of the Saturn rockets. The site for the MTO was announced on October 25, 1961. The Nova-class space vehicle concept was discarded in 1962.

Three main elements ran through the Saturn program: the launch vehicle, the ground support equipment, and the test and launch facilities. A detailed test site construction program for MTO was released by NASA on March 1, 1963.

The engineering and architectural firm of Sverdrup & Parcel and Associates of St. Louis, Missouri, would design the four static test stands that were planned for the Saturn V Apollo Moon rockets. These included a dual-position stand for testing the first stage S-1C with 7.5 million pounds of thrust, and two test stands for the second stage S-II with one million pounds of thrust. Located about 6,000 feet apart, each test complex consisted of a Test Control Center and about 20 support and service facilities: an engineering lab, acoustical lab, electronics and instrumentation lab, site-maintenance building, automotive shop, inflammable materials, storage, warehouses, railroad spur lines, telephone, emergency services, central control, data handling center, and fuel storage. A Central Control Center would serve the entire area.

Canals running adjacent to the test stands and back to the main canal system of the complex would be lined with docks for fuel and oxidizer barges, industrial water distribution, utilities, roadways, and a fire extinguishing system. A series of specialized ships, barges, and floating propellant tanks were constructed or altered to support the facility. Design work was to be completed in one year.

The Southern Railway System constructed a 10.5-mile railroad track into MTO to serve the area during the construction and operation phases. It ran from its New Orleans and North Eastern Railway (NO&NE) at Nicholson, Mississippi, to a terminal in the southwestern section of the MTO Fee Area and was completed in 52 days, ahead of schedule by 27 days.

The General Electric Company was contracted to provide plant and test support services, requiring 1,200 to 1,600 employees at peak operation after 1966.

Finally, the first, unique mosquito abatement program was organized for the area after at least 33 species of mosquitoes and several other insects such as black flies, deer flies, dog flies, sandflies, and the common housefly, were identified. The mosquito control unit was also responsible for general pest control, including fire ants, rodents, weeds, and brush control. Before the program was instituted, the US Army Corps of Engineers estimated work efficiency was lagging by at least 25 percent as some work crews simply walked off the job.

Mosquitoes alone posed an enormous problem with the 2,500 workers during construction. Head nets and repellants proved ineffective. A consultant entomologist and one field inspector were hired, and 10 miles of old logging roads were cleared and new roads built to allow fog trucks to travel around the site, providing immediate coverage.

Along with mosquito abatement came the issue of noise abatement, with NASA now owning the world's biggest noise generator. Pamphlets explaining the nature of noise in general and the nature of Saturn's noises in particular were distributed, assuring the local population that no physical harm or property damage would follow a test firing.

The Raytheon Company was contracted to establish an advanced atmospheric sounding station, accompanied by a weather station operated by the US Weather Bureau. Before each test fire, air temperature and wind conditions to 10,000 feet altitude were measured to determine if focusing conditions existed, causing a possible test fire delay.

On July 24, 1969, the main objective of winning the space race by landing the first man on the Moon and returning him safely to Earth had been accomplished. Less than one month later, the Mississippi Gulf Coast was devastated by the arrival of Hurricane Camille, and five months later the closure of the Mississippi Test Facility (MTF, renamed July 1, 1965) was announced.

Thanks to the efforts of MTF director Jackson M. Balch, and Sen. John C. Stennis, along with fellow senators from Mississippi and Louisiana, MTF remained open. Renamed National Space and Technology Laboratories (NSTL) on June 14, 1974, the site evolved into a federal city for scientific and technological endeavors, while continuing to support NASA's space missions. In 2016, Stennis Space Center (SSC, renamed on May 20, 1988), celebrated its "Golden Year of Engine Testing," 50 years of test fires that began with a 15-second firing of a Saturn V second stage prototype, S-II-C, on April 23, 1966.

In a 1961 letter to George Alexander, a writer with *Aviation Week*, Dr. Wernher von Braun described how the purpose of the Mississippi Test Operations was to provide the capability to captive test fire large space vehicles for at least "the next twenty-five to fifty years."

One

"Taking Part in Greatness"

November 1, 1961

The Soviet Union's successful launch of *Sputnik* amid ongoing Cold War tensions compelled Pres. Dwight D. Eisenhower to dissolve the National Advisory Committee for Aeronautics (NACA), founded in 1917. On July 29, 1958, he signed the National Aeronautics and Space Act that created the more expansive and well funded National Aeronautics and Space Administration (NASA).

Almost immediately, the search began for sites that would accommodate the four field installations reporting to the Marshall Space Flight Center (MSFC) in Huntsville. By the fall of 1961, three of the four locations had been chosen: a laboratory known as the Manned Spacecraft Center in Houston, Texas; Michoud Assembly Facility for manufacturing in New Orleans, Louisiana; and a launch site at Cape Canaveral, Florida.

The location for rocket propulsion testing would have to meet even more restrictive requirements: relative isolation, accessible by water and highway, a climate permitting year-round testing, and proximity to Michoud Assembly Facility. The piney woods and cypress swamps along the Pearl River in the extreme southwestern part of Mississippi, not far inland from the Gulf of Mexico, appeared to be the ideal location.

Several historic 18th-century lumber towns and communities were sacrificed, and approximately 700 families relocated to form the combined 116,650-acre Fee Area and Buffer Zone that would absorb noise and vibration. These included the oldest, Napoleon, that occupied an original British land grant from 1798. Gainesville, founded in 1810, became the county seat of Hancock County. Logtown, originally settled by the French, eventually boasted a population of 3,000 residents. Westonia was an inland railroad town for the transportation of milled lumber.

On All Saints Day, November 1, 1961, Sen. John C. Stennis stood on a flatbed trailer in Logtown and assured the aforementioned families that they would be fully compensated for their properties by the US government's use of eminent domain. Appealing to the crowd's innate patriotism, the senator told them, "You have got to make sacrifices but you will be taking part in greatness." The Mississippi Test Operations became MSFC's fourth field installation.

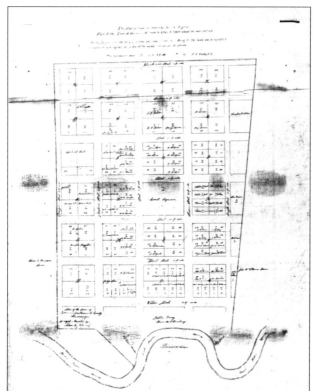

Gainesville was the largest town in Hancock County. This 1938 plat shows a public quay, steamboat landing, shipyard, lumber mill, and steam line dock along the banks of the Pearl River. The town itself was laid out following an orderly grid pattern with a court square in the center. Farms and forests surrounded the town on the remaining three sides. (Courtesy of Hancock County Historical Society.)

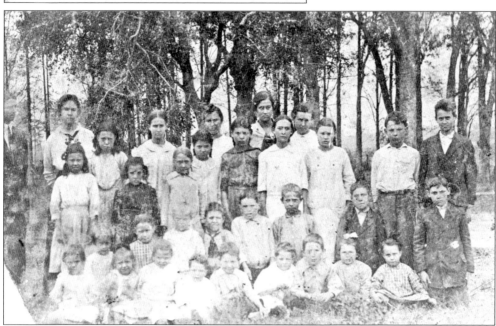

Students of the Aaron Academy gather for their annual class portrait in the community of Santa Rosa in this undated photograph. Named by William Wesley Frierson, a lumber mill owner, in honor of his father, Aaron Frierson, the coed school conducted classes from the first through the eighth grade; high school was in nearby Kiln. (Courtesy of NASA.)

In the early 1900s, a group of young people set out for a leisurely buggy ride in the vicinity of either Logtown or Pearlington. The buggy was a light, four-wheel carriage whose enormously high wheels helped the vehicle manage the mostly dirt, and sometimes muddy, roads. By 1900, mail-order catalogs advertised simple vehicles for as little as $20. (Courtesy of Hancock County Historical Society.)

Ethel Otis, the daughter of a prominent lumber mill family in Logtown, poses in her new car, with its steering wheel on the right, under a canopy of Spanish moss. After 1908, the Ford Motor Company's Model T changed the wheel to the left, making it easier for passengers to enter the car while avoiding oncoming traffic. (Courtesy of Hancock County Historical Society.)

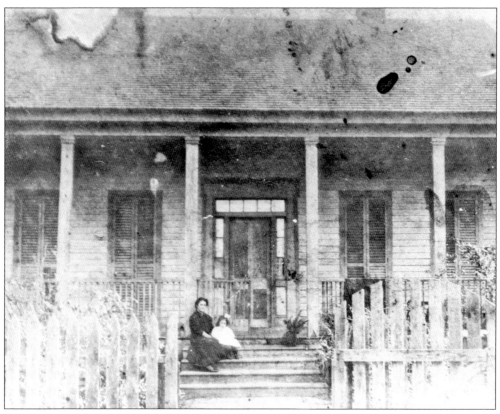

Built in 1805, the Carver Home was located in what became known as Gainesville, a town incorporated in 1846. Sitting on the steps in 1905 are Zora Holcomb (left) and Alice Petermen. During the 20th century, the house was owned by Mrs. John Henry Petermen before being sold to the US government and demolished in the early 1960s. (Courtesy of Hancock County Historical Society.)

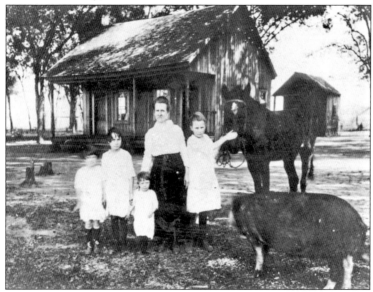

Dicy Frierson McQueen, wife of Johnny McQueen (not pictured), and their four children, all wearing their Sunday-best outfits, stand before their home in Gainesville for a formal portrait accompanied by their horse and sow in this undated photograph. (Courtesy of NASA.)

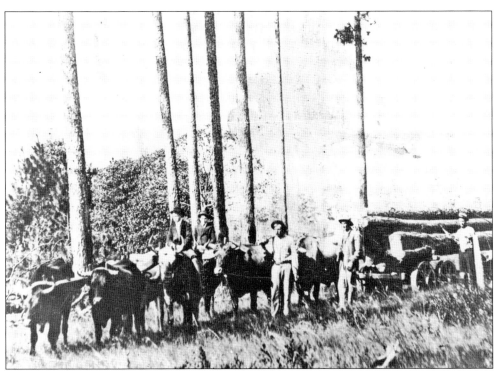

Logs that were unreachable by a skidder were loaded onto wagons pulled by bulls or oxen, sometimes for several miles, before reaching the sawmill. (Courtesy of Hancock County Historical Society.)

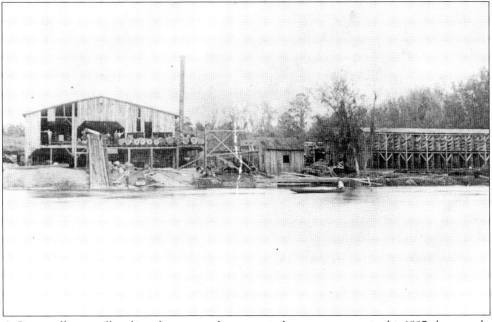

A Gainesville sawmill and its adjacent warehouse await the next customer in this 1897 photograph. A lone forester plies the relatively calm waters of the Pearl River on this day. Many lumber mills, such as the mill pictured, would proclaim themselves to be the largest mill in the United States. (Courtesy of Hancock County Historical Society.)

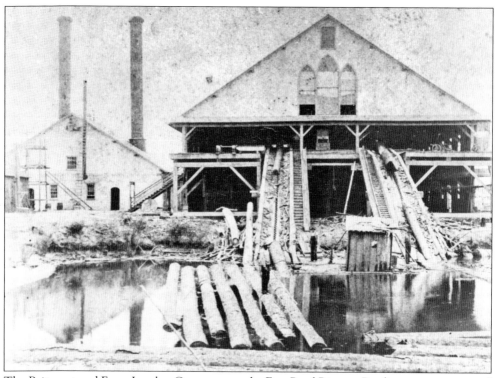

The Poitevent and Favre Lumber Company, on the East Pearl River at Pearlington, was reported to be the largest sawmill in the United States on July 4, 1890. Dubbed "Big Jim," the mill had a capacity of 200,000 board feet per day. (Courtesy of Hancock County Historical Society.)

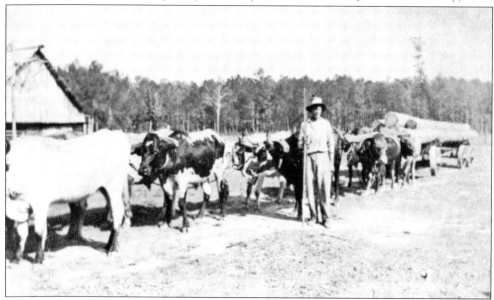

Bill Favre brings his team of bulls, or oxen, from the pine forests. Known as the "poor man's power" since the 1800s, oxen (castrated males), had and still have a low initial cost, the ability to work long hours, and a lengthy lifespan. (Courtesy of McCain Library and Archives, University of Southern Mississippi, Hattiesburg.)

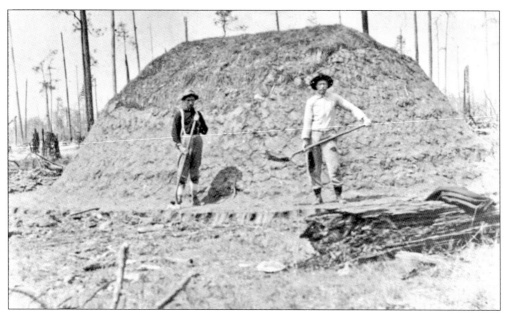

Two men work a charcoal kiln in Gainesville in 1912. Charcoal was an outgrowth of the lumber industry, used for heating in large cities. A large amount of charcoal was shipped to New Orleans by schooner. Both the kiln and the schooner were owned by Oscar Dean. (Courtesy of McCain Library and Archives, University of Southern Mississippi, Hattiesburg.)

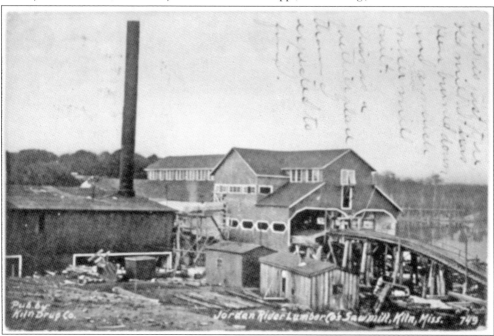

The Jordan River Lumber Company's sawmill in Kiln, Mississippi, was "a prettier place than I expected to find," according to the inscription on this postcard. Kiln was named for the immense kilns in which the original French settlers burned charcoal for sale. By 1910, the town of Kiln was also known as the "Moonshine Capital of the Nation." (Courtesy of McCain Library and Archives, University of Southern Mississippi, Hattiesburg.)

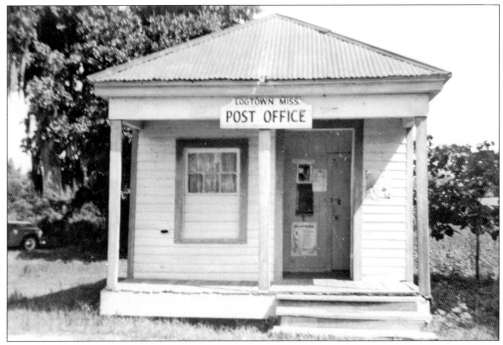

The Logtown Post Office is pictured in the 1940s. Postmaster Lollie Bell Wright held the position for 36 years before learning that NASA would be building a test facility in Hancock County. Constructed in 1883, the building also served as the Logtown branch of the Hancock Bank from 1919 to 1927. (Courtesy of Hancock County Historical Society.)

A senior citizen holds a child, possibly a relative, in front of the Blue Ribbon School, founded in 1908, in an undated photograph. According to *A Boy in Rural Mississippi*, the school stood within the area that is now the Stennis Space Center. (Courtesy of McCain Library and Archives, University of Southern Mississippi, Hattiesburg.)

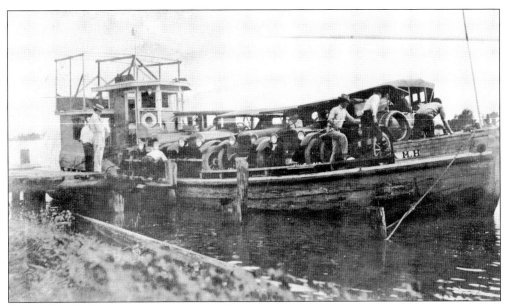

An automobile ferry on the Pearl River readies its cargo for a trip to Bay St. Louis in this undated photograph. A two-hour trip cost $6 for car and passengers. It was advised to telephone ahead to the H. Weston Lumber Co. for a "trip through the bayous of Pearl River." (Courtesy of Hancock County Historical Society.)

Mail arrived daily via the mail boat *Pelican* at Logtown for distribution to surrounding communities. (Courtesy of Hancock County Historical Society.)

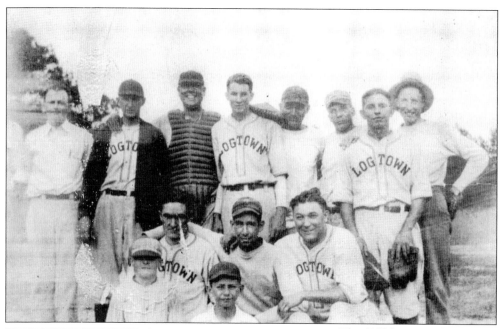

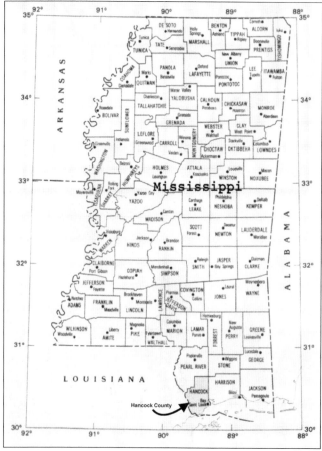

The 1932 Logtown Tomcats baseball team consisted of, from left to right, (first row) bat boys Buster Summers and Ted Casanova; (second row) Sam Whitfield, M. Douglas, and Forrest Summers; (third row) manager Coney Weston, Louie Summers, Floyd Booth, John Summers, Ames Russ, Harry Baxter, John Kerr, and Joe Casanova. (Courtesy of Hancock County Historical Society.)

The US Army Corps of Engineers, Mobile District, began acquiring land in April 1962, not to exceed a total cost of $16 million in this southwestern part of Mississippi near the Louisiana border. (Courtesy of Hancock County Historical Society.)

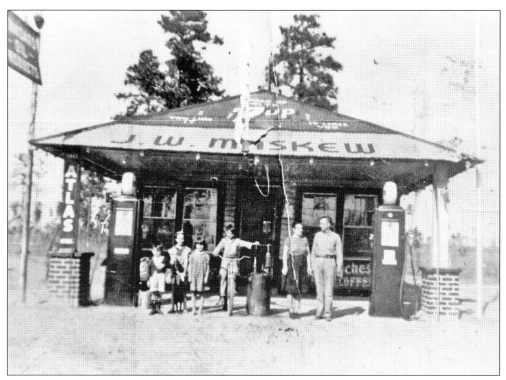

The J.W. Maskew family owned this gas station near the intersection of Highways 90 and 607 before World War II. In 1961, their four-acre property was inside the Buffer Zone. The family agreed to a perpetual easement, restricting certain uses in, on, over, and across the land not conducive to habitation because of the anticipated effects of sonic vibration. (Courtesy of Hancock County Historical Society.)

The children of Columbus and Molly Davis Penton anticipate their move from Gainesville. In 1961, the US Army Corps of Engineers placed a fair market value of $200 per acre for land in the Fee Area. An acoustic buffer-zone easement commanded $75 per acre. (Courtesy Hancock County Historical Society.)

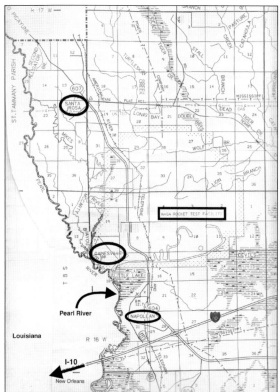

The attributes of Hancock County as a center for lumber and its by-products are similar to those for a rocket test facility: year-round, ice-free water access, isolation from population centers, close to support communities, but with one exception: proximity to Michoud Assembly Facility, which would construct the booster engines, and Cape Canaveral, the launch facility. (Courtesy of Hancock County Historical Society.)

Despite its hospitable invitation above the main double-screened door that reads "Welcome Napoleon Baptist Church," the picturesque Napoleon Baptist Church, located inside the Buffer Zone, was eventually demolished. The community of Napoleon had been named for either the emperor Napoleon Bonaparte of France, or his brother, Joseph. (Courtesy of Hancock County Historical Society.)

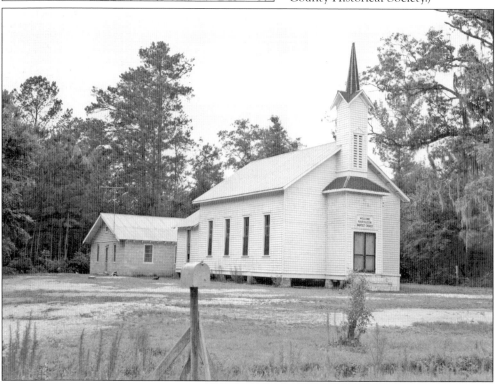

The Blue Goose (right) was a floating whiskey saloon docked on the Louisiana side of the Pearl River in 1908. Bars serving alcoholic beverages were legal on the Louisiana side of the river, while Hancock County remained a "dry" county. (Courtesy Hancock County Historical Society.)

A family home inside the Fee Area sits beneath the shade provided by the towering pine trees in Gainesville, while the laundry dries on the clothesline. The family automobile, a 1959 Chevrolet Impala, is parked in front of the gated fence. Land acquisition began in 1962. (Courtesy Hancock County Historical Society.)

A brand-new 1955 two-tone (blue and white) Chevrolet Bel Air is parked in front of a carefully manicured family home in Gainesville, within the Fee Area of the test site. Residents had been assured that the federal government would conduct a smooth transition to other locations. (Courtesy of Hancock County Historical Society.)

Prior to the 1961 NASA announcement, two brothers stand in front of their home in Gainesville to have their picture taken, accompanied by a sizable propane tank used for the home's heating and cooking requirements. It seemed like every person in the county expressed surprise at the government's sudden announcement in November 1961 and the speed with which changes were occurring. (Courtesy of Hancock County Historical Society.)

Cora Ethyl Davis sits on her porch after tending to her chickens. Known as Granny Blue, she said, "I don't believe I could stand to move. There ain't no place like home." Her home and her chickens were moved to nearby Picayune, Mississippi. (Courtesy of Hancock County Historical Society.)

A 1955 Ford Fairlane is parked beside a small store sheathed in weathered clapboards, while children play in back of the house next door on an early summer day in Logtown, Mississippi. By May 29, 1963, everything pictured was days or weeks away from being torn down for the new rocket testing facility. (Courtesy of NASA.)

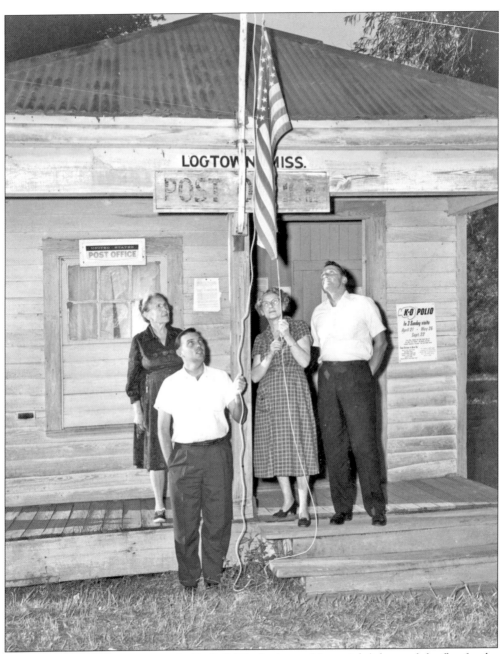

In 1963, the longtime postmaster, Lollie Bell Wright (second from right), lowered the flag for the last time at the Logtown Post Office. Standing next to Wright is Roy Baxter (right), the owner of the post office building, with two unidentified residents. The last bag of mail had just been delivered. The notice nailed to the building on the right urges citizens to "K-O Polio." (Courtesy of NASA.)

Two

FROM CYPRESS SWAMP TO SPACE

1961–1966

Representatives of the Real Estate Division of the US Army Corps of Engineers were establishing their field office for land acquisition operations by late October 1961. Mississippi Democratic senator John C. Stennis was simultaneously assuring families living in the Buffer Zone that they would be given up to two and a half years to relocate. The senator had estimates of approximately $13.5 million for land acquisition and easements.

The test area would encompass a 13,550-acre construction site, or Fee Area, in Hancock County with a surrounding restrictive Buffer Zone containing 101,300 acres also in Hancock County, 1,800 acres in Pearl River County, and 25,300 acres in St. Tammany Parish, Louisiana, or a total of 141,950 acres of land.

The first payments went to Samantha B. Kellar on May 2, 1962, for her home and 12 acres of land in the Fee Area, and to Mr. and Mrs. Elvie Dakes Roberson on May 28, 1962, for their home and 22 acres of land in the Buffer Zone.

Mississippi Test Operations (MTO) was constructed and operated as part of NASA Marshall Space Flight Center in Huntsville under the direction of the NASA Headquarters Office of Manned Space Flight. Capt. William C. Fortune, US Navy, was chosen as manager of the NASA MTO on October 1, 1962, and wasted no time initiating an "all-up" mobilization of its construction program.

The former Rouchon and Geraci residences were converted to offices, while Margaret Tingle McCormick became the first hired employee. In 1963, contracts were awarded to Sverdrup & Parcel and Associates Inc. of St. Louis, Missouri, for the design of the rocket test complex.

NASA Public Relations initiated a series of space exhibits, movies, and lectures for the high schools in Pearl River, Hancock, and Harrison Counties. An MTO information center opened 10 miles south of Picayune, Mississippi, on MS Highway 43, while orientation visits for citizens, businessmen, and government officials were scheduled.

On April 23, 1966, the S-II-T stage was successfully test fired in the A-2 Test Stand while site construction continued.

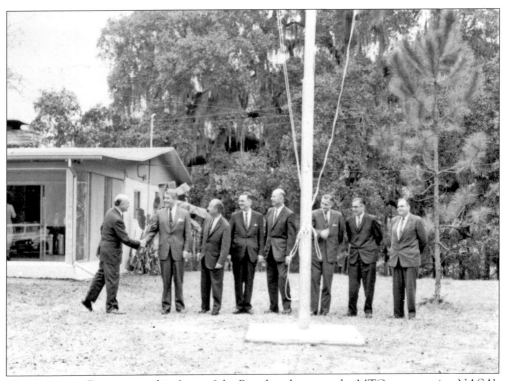

The American flag was raised in front of the Rouchon house at the MTO, announcing NASA's presence in 1962. Pictured from left to right are Bart Slattery, public affairs; Dr. Wernher von Braun, director; Capt. William Fortune, manager; Dr. George Constan, Michoud Assembly Facility; Dr. Oswald Lange, Saturn program office; Dr. Hermann Weidener, Structures and Mechanics Laboratory; and Dr. Karl Heimburg and Dan Driscoll, both of the Astronautics Laboratory. (Courtesy of NASA.)

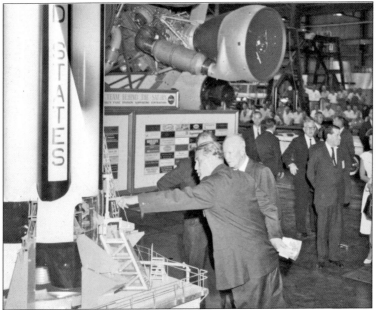

Dr. Wernher von Braun, Marshall Space Flight Center's first director, describes the details of a scale model S1-B rocket to Pres. Dwight D. Eisenhower during the center's dedication ceremony on September 8, 1960. (Courtesy of NASA.)

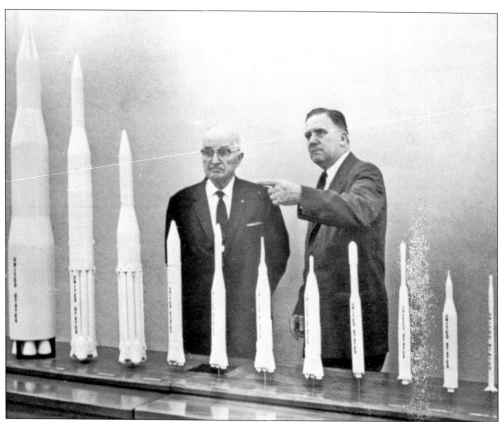

NASA administrator James Webb (right) presents an array of 11 scale-model rockets for display at the Harry S. Truman Presidential Library and Museum in 1961. The models range from the enormous "Nova" rocket at left to the small "Scout" at right. The 77-year-old President Truman commented that if he were 21 again, he might be a candidate for the first flight to the Moon. (Author's collection.)

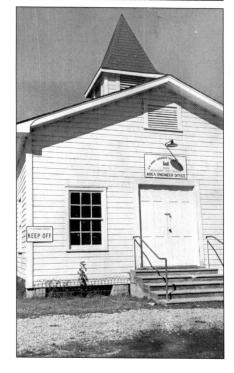

The former Baptist church in Gainesville was converted to the area engineer office for the US Army Corps of Engineers, NASA Mississippi Test Facility. On January 10, 1963, the town of Gainesville ceased to exist. (Author's collection.)

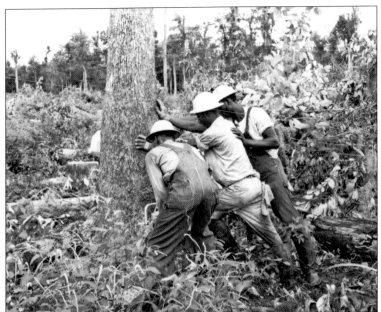

Work crews cut down the first trees at the Mississippi Test Facility, signaling the start of facility construction. The trees were cut in Devil's Swamp near the construction dock on the turn basin, part of the future seven-and-a-half-mile, man-made canal system for the facility. (Courtesy of NASA.)

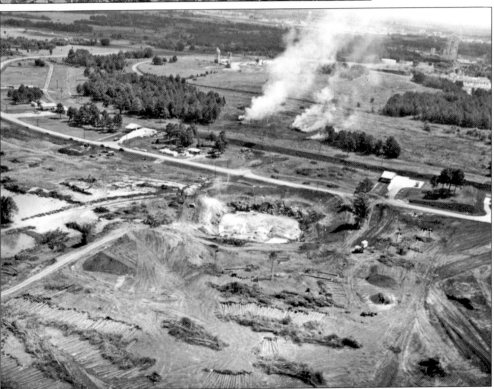

The excavated pit (center) is the future location of the dual position B-1/B-2 Test Stand. Employing "deep foundation" construction methods, i.e., increasing the depth or area of the foundation system proportional to the magnitude of the total load on the foundation system, the concrete and steel stand has a base larger than a football field with a foundation extending 40 feet below ground. (Courtesy of NASA.)

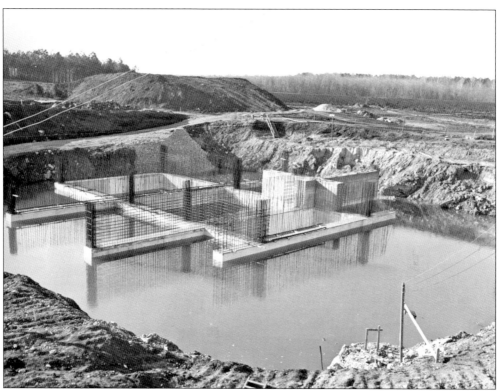

During construction of the B-1/B-2 Test Stand, southwest Mississippi experienced unusually high levels of rainfall that increasingly hampered construction. The incomplete foundation is resting on 1,640 steel pilings, each over 90 feet long. (Courtesy of NASA.)

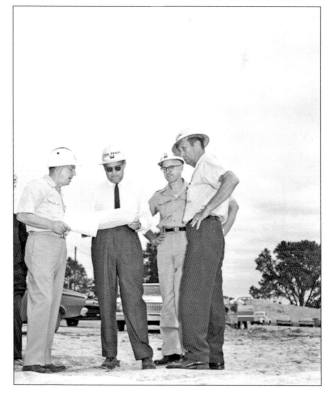

From left to right, Capt. William C. Fortune, first site manager of Mississippi Test Operations; Dr. Wernher von Braun, first director of Marshall Space Flight Center; and two unidentified representatives from the US Army Corps of Engineers consult their plans during the start of construction of the Mississippi Test Operations in the early 1960s. (Courtesy of NASA.)

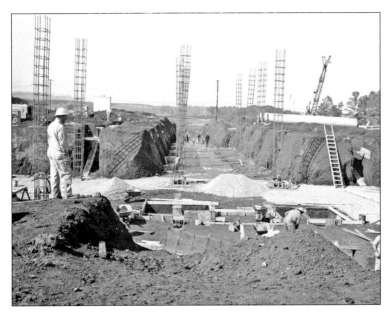

Work continues on the pump house for the B-1/B-2 Test Stand, which will deliver water at a rate of 320,000 gallons per minute through the test stand's deflector, dissipating a major portion of the flame. The dual-position B-1/B-2 Test Stand, was built to withstand the S-1C's five F-1 rocket engines, which together generate 7.5 million pounds of thrust. (Courtesy of NASA.)

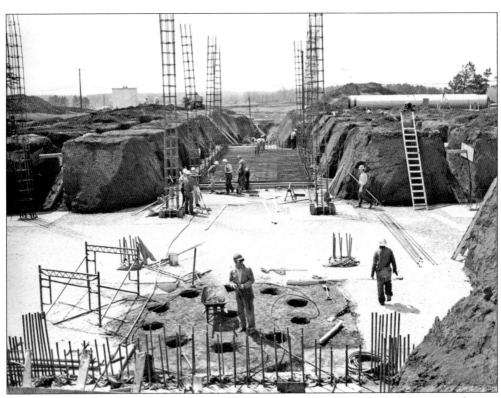

The B-1/B-2 Test Stand's pump house will send water through the 90-foot-high deflectors, with more than 78,000 perforations, to dissipate the flame and a temperature of 5,500° F generated by the five F-1 rocket engines during a test fire. A separate emergency water system is capable of flooding all or part of the stand with 123,000 gallons of water per minute. (Courtesy of NASA.)

An access tunnel leads to the Test Control Center for the B-1/B-2 Test Stand rising in the background. The Control Center and Data Acquisition Facility, similar to a "block house," allows for observation and recording of static test fires from a safe distance. Each test stand is part of a test complex consisting of a Test Control Center and approximately 20 support and service facilities. (Courtesy of NASA.)

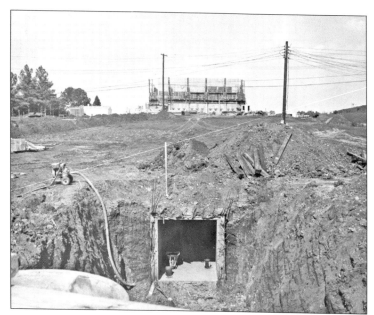

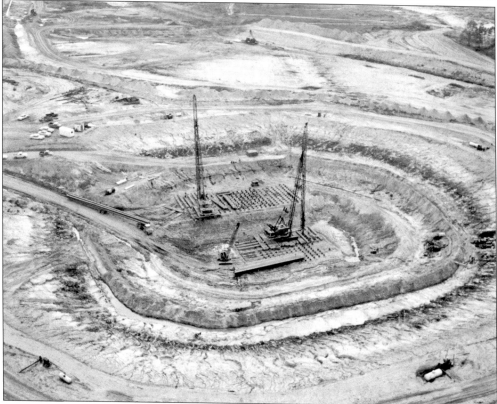

The A-2 Test Stand also employed deep foundation construction methods. Two pile drivers sent 90-foot-long pilings into the ground, while excavation went down 50 feet with steel H-beams driven 100 feet deeper to form a foundation for the huge piers of the test stand. The A-2 Test Stand is one of two built to test the S-II second stage of the Apollo/Saturn V. (Courtesy of NASA.)

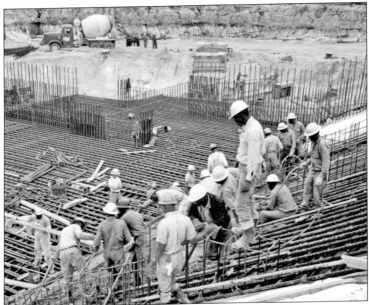

Construction crews install steel reinforcing rods at the base of what will become the A-2 Test Stand in 1964. The reinforced concrete base extends 40 feet below ground. On April 23, 1966, the S-II-T was successfully static-fired, serving to check out both the facilities of the test stand and to train the test crews and support personnel. (Courtesy of NASA.)

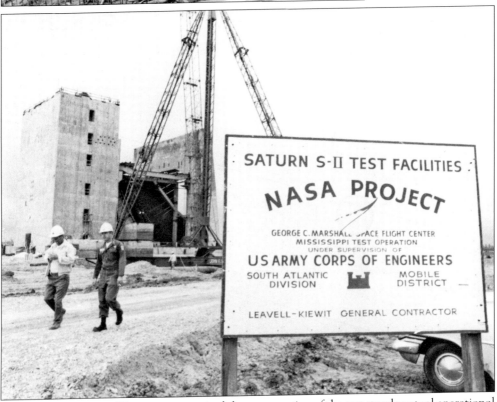

The US Army Corps of Engineers supervised the construction of the test stands; actual operational responsibility for the A-1 and A-2 Test Stands went to North American Rockwell Inc. The data for test evaluation was recorded and processed in the Data Acquisition Facility and Data Handling Center by technicians of General Electric's Mississippi Support Department. (Courtesy of NASA.)

Special overlaid plywood called Fiber-Ply, developed by Georgia-Pacific Corporation, is being stripped from the 102-foot level of the A-2 Test Stand. Speed of construction required that the same plywood concrete forms be reused many times and that each concrete pour be extremely smooth surfaced. The forming panels were rushed to the site from the Georgia-Pacific Mill in Springfield, Oregon. (Author's collection.)

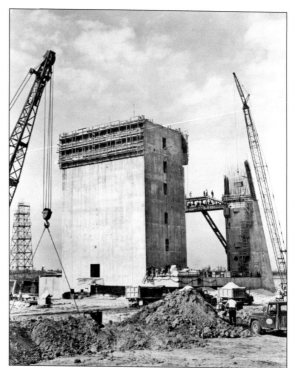

The A-2 Test Stand rises 200 feet above ground, with overhead cranes. The steel superstructure consists of load and work platforms, utility and data measuring systems, elevators, stage handling derricks, hold-down equipment, aspirators, and flame deflectors. Its reinforced concrete foundation rests on steel piles that extend 90 feet into the ground. (Author's collection.)

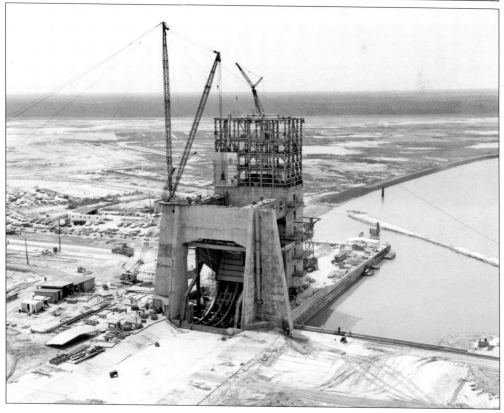

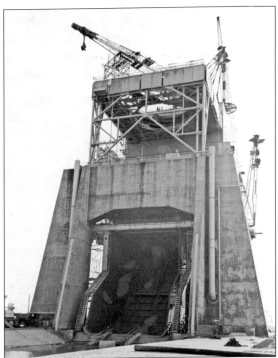

The flame deflector on the A-2 Test Stand is 53 feet high, 40 feet wide, and constructed of plate steel. The five J-2 rocket engines on the S-II second stage generate enough heat for the steel plates to reach a temperature of 4,000° F during a firing. Water is pumped through holes in the plates at the rate of 170,000 gallons per minute. (Author's collection.)

The A-2 Test Stand awaits its first test fire with its support and service facilities, such as the cryogenic barges (right), in place. Water used to dissipate a major portion of the flames and heat from the rocket engines is pumped from a 66-million-gallon reservoir (top left) to the test stand via 12 high-pressure diesel pumps. (Author's collection.)

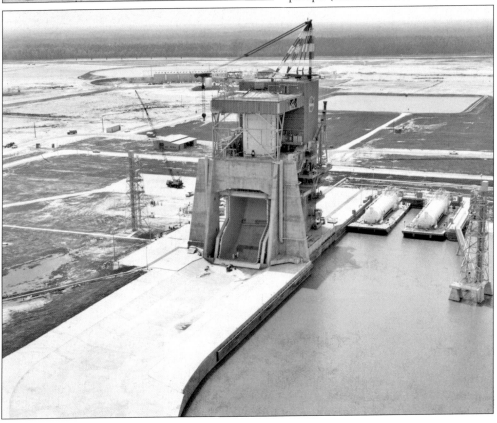

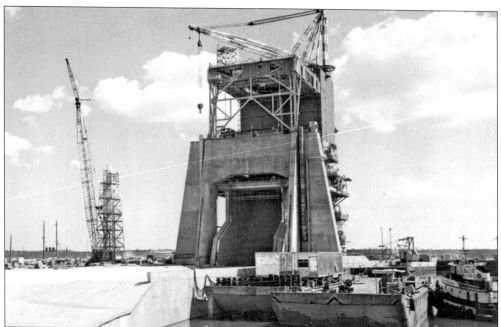

The A-2 (and later the A-1) Test Stands were designed specifically to test the S-II second stage of the Saturn V and are positioned 2,300 feet apart. As part of the checkout and flight acceptance testing, instruments are located on the test stand, on the flight stage or rocket, and on towers near the stand, such as the tower on the left near a crane. (Author's collection.)

This back view of the A-2 Test Stand shows piping and conduits for measurements of the test stand itself during a test fire. These measurements include water pressure on the flame deflector and hydrogen, nitrogen, and helium pressures on the test stand that control the test. (Author's collection.)

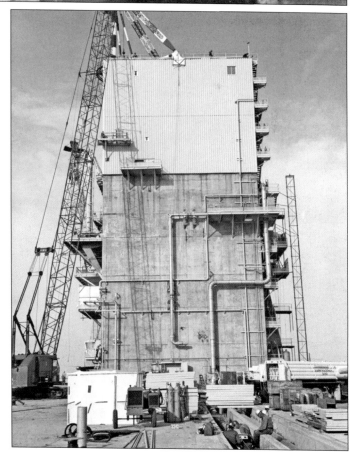

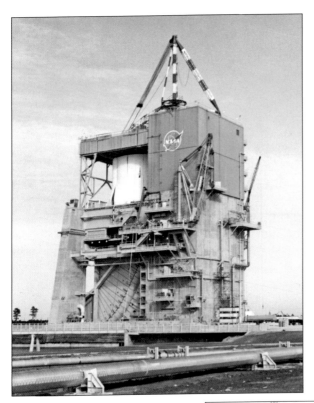

This corner view of the A-2 Test Stand shows ground support equipment, piping, and conduits that enable measurements of equipment such as heat exchangers on the test stand that provide conditioned nitrogen, helium, and hydrogen to the stage for purges and pressurization, and hydrogen and liquid oxygen from the barge systems. (Author's collection.)

This side view of the A-2 Test Stand shows how it is designed to allow the stages and engines to be locked in place, ignited to develop full thrust, and function as they would in space. The stage's flight worthiness is determined via measurements of temperatures, fuel flow, vibrations, thrust, position, strain, pressures, and hundreds of other factors recorded for analysis and evaluation. (Author's collection.)

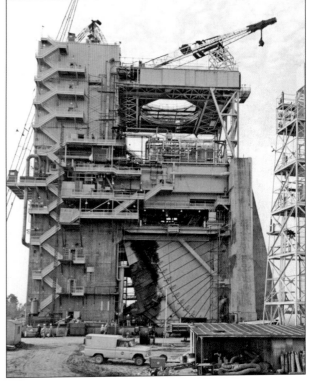

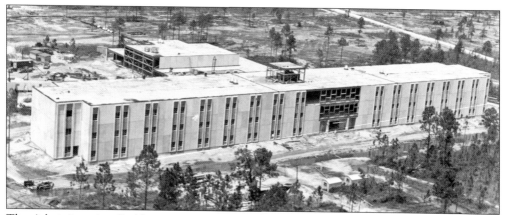

The Administration Building was nearing completion on September 29, 1964. It served as the administrative headquarters for NASA and its prime contractors: Boeing, North American Aviation, and General Electric. Building 1100 was one of approximately 30 construction projects at MTO in 1964. (Author's collection.)

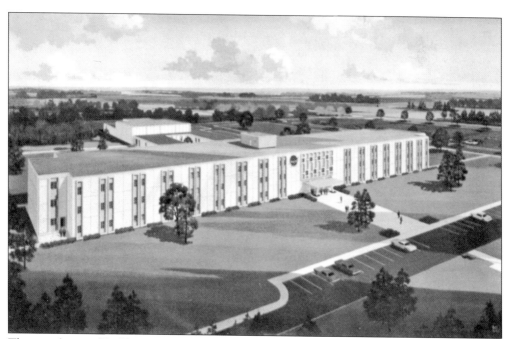

The completion of Building 1100, or the Administration Building, was considered a milestone during the construction phase of Mississippi Test Facility when it opened on January 19, 1965, allowing NASA and contractor personnel to move from temporary quarters. (Author's collection.)

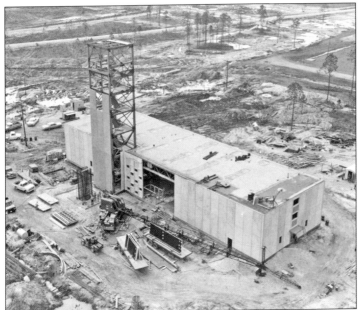

The Central Control Building, or Building 1200, was designed in 1963 by Sverdrup & Parcel and Associates Inc. of St. Louis, Missouri, under the direction of Dr. Wernher von Braun. The steel-frame structure has exterior walls that include five-inch-thick precast concrete panels and a six-inch-thick inner wall of concrete masonry units. It was designed to resist acoustic overpressure from static test blasts. (Courtesy of NASA.)

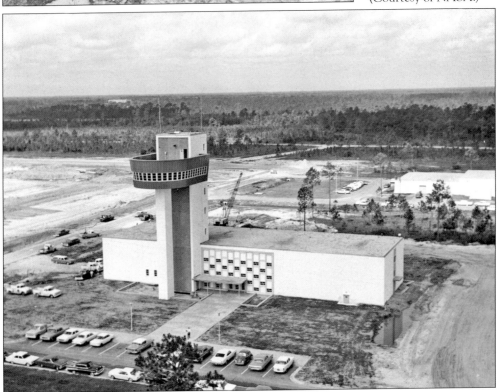

Sometimes known as the "von Braun Tower," the concrete cantilever of the Observation Area floor and roof are lightweight structural concrete with reinforcing steel in a radial pattern tied to bars running vertically in the central column underneath. A safe 7,500 feet from the A-2 Test Stand, the tower provided an observation point for engineers, media, and visiting dignitaries to view the dramatic test fires. (Courtesy of NASA.)

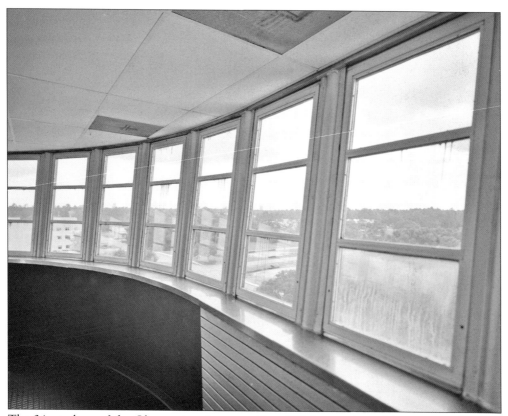

The 34 windows of the Observation Area provide a 270-degree view of the test complexes. A 100-foot-wide direct line of sight between the test stands and the 90-foot-tall tower offered the choice of an enclosed observation platform or a rooftop observation deck to study the noise and vibration of a rocket engine test. (Courtesy of Library of Congress.)

Construction work continued on New Year's Eve 1963, despite an extremely rare snowfall of four inches. The owner of the brand-new 1963 Chevrolet Bel Air almost appears to be stuck in the snow. The sign reads "Warrior Construction Personnel Parking." (Courtesy of NASA.)

The snow has not stopped at the Rouchon house, NASA's temporary headquarters, as work continues on New Year's Eve 1963. Four inches of snow had fallen by nightfall on the site formerly known as Gainesville. The cars are (from left to right) a 1957 Ford Fairlane, a 1959 Pontiac Bonneville Safari station wagon, a 1962 Chevrolet Bel Air, and a 1961 Dodge Lancer. (Courtesy of NASA.)

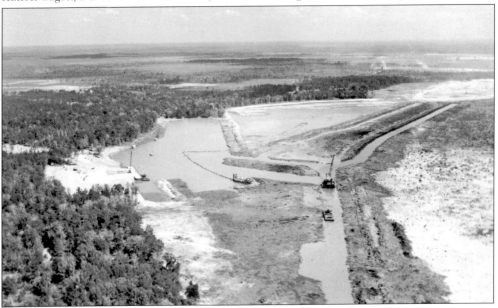

Waterways were essential to moving heavy construction materials and the flight stages from the West Coast and Louisiana to the test stands. The East Pearl River was dredged about 15 miles from the Intracoastal Waterway to the test site, seven and a half miles of canals within the main complex were excavated, and a lock system was built to connect the Pearl River with the interior canal system. (Courtesy of NASA.)

The Nordberg water pumps at the High Pressure Industrial Water Facility (HPIW), shown in 1966, provide water for cooling the flame deflectors at the test complexes during static test firings. A separate emergency water deluge system on each test stand can flood all or part of the stand with 123,000 gallons of water per minute. (Courtesy of NASA.)

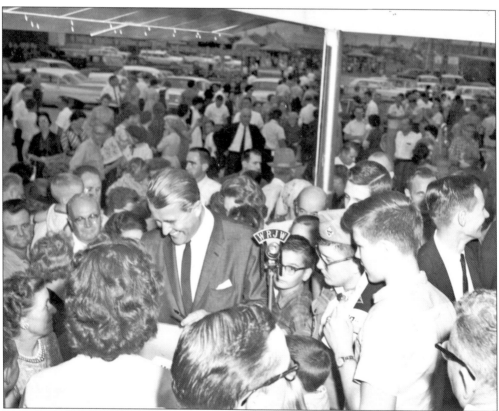

Dr. Wernher von Braun signs autographs for an enthusiastic crowd at the Gulf South State Fair in Picayune, Mississippi, in October 1963. During his visit, Dr. von Braun spoke to employees of NASA and the Army Corps of Engineers, and met with local citizens. (Courtesy of NASA.)

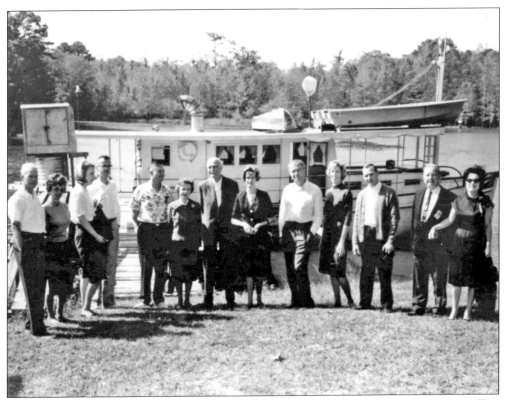

While vacationing on the Gulf Coast, the von Brauns and guests arrived at the Mississippi Test Operations on October 26, 1964, aboard the *Doris* M., the Seal family boat. From left to right are Mr. and Mrs. Donald Suter; Dr. von Braun's sister-in-law; Fred Wagner; Mr. and Mrs. Dallas Stanton; Magnus von Braun; Maria and Wernher von Braun; Mrs. Virginia Seal Wagner; Jack Thompson; and Capt. and Mrs. William Fortune. (Courtesy of NASA.)

Jackson M. Balch (right), manager of the Mississippi Test Facility, became the new president of the Mississippi Coast Association of Federal Administrators on October 4, 1966. He led efforts to transition from a single-mission operation to a multiagency facility. He replaced Comdr. N.L. Martinson (left) of the US Naval Construction Battalion Center in Gulfport, Mississippi, after his transfer to California. (Author's collection.)

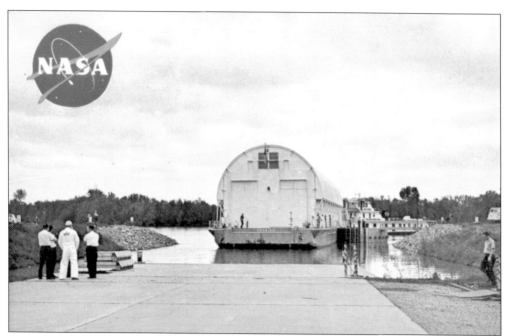

This official NASA postcard pictures the barge *Promise*, which transported Saturn booster rockets, about to dock at a facility on the Tennessee River near Marshall Space Flight Center in Huntsville. Waterways, both natural and man-made, were indispensable to the movement of space hardware. (Author's collection.)

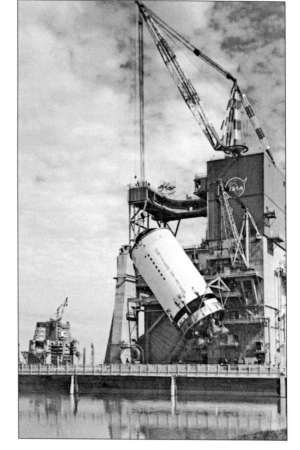

An official NASA-MTF photograph was made into a postcard to explain how the S-II-2, the second stage destined for the second flight of the Saturn V space vehicle, is being hoisted into the A-2 Test Stand for static firing and checkout. The B-1/B-2 Test Stand is to the left rear. (Author's collection.)

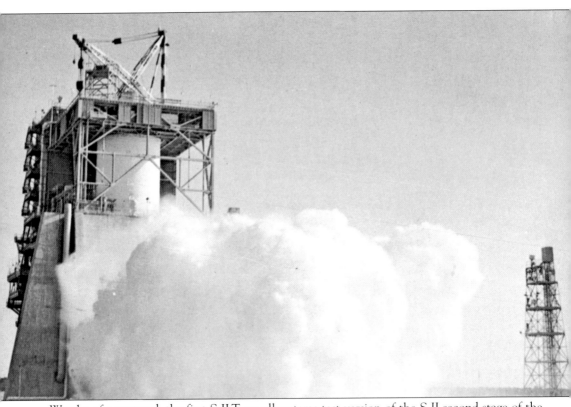

Worthy of a postcard, the first S-II-T, an all-systems test version of the S-II second stage of the Saturn V space vehicle, is shown in the A-2 Test Stand. It was the facility's first, and successful, test fire on April 23, 1966. The A-1 Test Stand was under construction; both stands tested the S-II second stage. (Author's collection.)

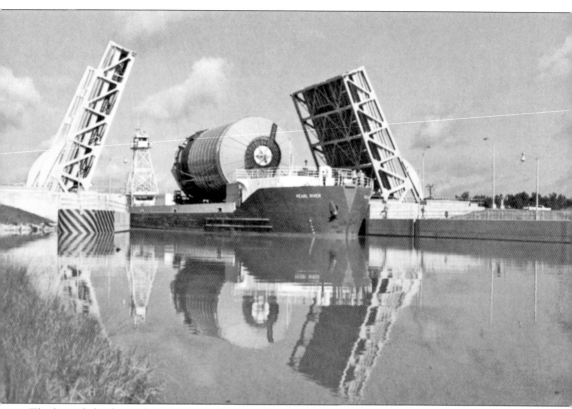

The bascule bridge at the Mississippi Test Facility opens for the NASA barge *Pearl River*, carrying an S-II rocket, second stage of the Saturn V space vehicle. The barge first entered the man-made canal via the Pearl River Water Lock, which lifted the barge as much as 20 feet from the Pearl River's sea level elevation. The barge then proceeded to the A-2 Test Stand. (Author's collection.)

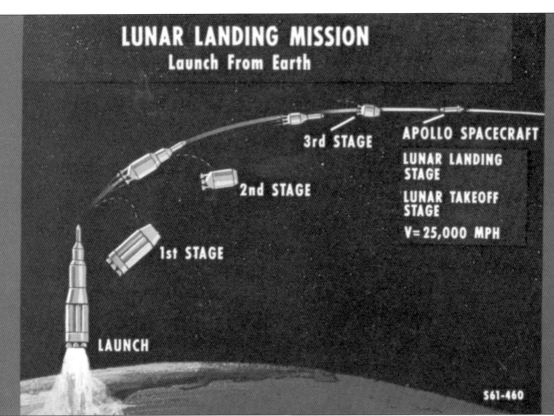

LUNAR LANDING MISSION
Launch From Earth

3rd STAGE

APOLLO SPACECRAFT

LUNAR LANDING STAGE

LUNAR TAKEOFF STAGE

V= 25,000 MPH

2nd STAGE

1st STAGE

LAUNCH

S61-460

This 1961 postcard shows an artist's conceptual drawing of the main objective of Project Apollo. Stated on the back of the card is the following: "The project is concerned with the development of a three-man space craft for up to two weeks' orbit about the Earth, flights around the Moon, and manned lunar landing." (Author's collection.)

Three

APOLLO IN THE PINES
1963–1974

During peak construction, the Mississippi Test Operations received a new name and new director. NASA director Dr. Wernher von Braun appointed Jackson M. Balch in May 1965 as director of the Mississippi Test Facility (MTF) . Meanwhile, at other sites, beginning on October 27, 1961, a total of 10 Saturn I vehicles, or "Baby" Saturns, were launched—proving techniques, technologies, and sometimes actual hardware prior to the giant Saturn V launch vehicles. At MTF, the lines between construction, activation, and operation continued to blur.

Landowners were still vacating their properties, while everyone battled mud, mosquitoes, a particularly unusual rainy season, and a variety of native wildlife that included 42 species of snakes (seven of which were venomous), and swamp razorback pigs.

In October 1963, NASA decided that the Saturn I program of unmanned research and development flight vehicles, using inoperative stages, would end; it would increase the use of the more powerful Saturn 1B vehicle to launch Apollo manned flights in preparation for the Saturn V's manned Moon mission.

On January 19, 1965, significant activation began with the completion of Building 1100, housing NASA and its contractors. This was followed by the May 20, 1966, test fire of the S-II second stage in the newly constructed A-2 Test Stand, making MTF operational.

The year 1968 was the busiest for testing. By mid-March, all three test stands were filled with Apollo/Saturn V flight stages. Two stands each contained the S-II-4 and the S-II-5 second stages for the fourth and fifth Saturn V rockets, while a third test stand held a Saturn V S-1C-6 first stage, destined for the sixth Saturn V launch. That year, nine flight boosters were scheduled for checkout and flight certification at MTF.

With the ultimate objective of a Moon landing one year away, Director Balch and Senator Stennis began to examine the role of MTF in NASA's future plans.

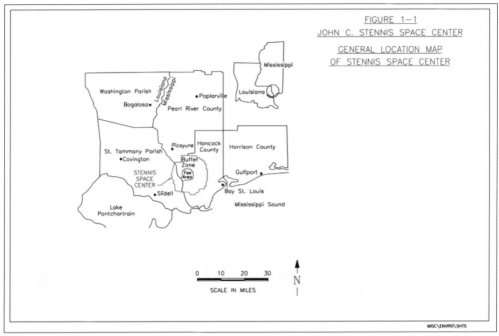

Mississippi

Louisiana

Washington Parish
Bogalosa•
•Poplarville
Pearl River County

Louisiana
Mississippi

Picayune
St. Tammany Parish
•Covington
Hancock County
Buffer Zone
Fee Area
STENNIS SPACE CENTER
•Slidell
Bay St. Louis

Harrison County

Gulfport

Lake Pontchartrain
Mississippi Sound

0 10 20 30
SCALE IN MILES

N

MISC\ENVIRO\SHT5

By 1966, the newly renamed Mississippi Test Facility became operational. Based on test fire data at Marshall Space Flight Center in Huntsville, the circles represented sound levels produced by area rocket testing. The Fee Area could receive 125 decibels, while the Buffer Zone could receive 110 decibels and absorb the sound reverberations of 20 million pounds of thrust. (Courtesy of NASA.)

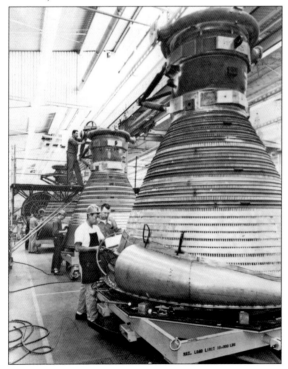

The F-1, the most powerful rocket in the free world, is shown during assembly at North American Aviation's Rocketdyne Division in Canoga Park, California. Each engine produced 1.5 million pounds of thrust. When clustered in a quincunx pattern at the bottom of an S-1C first stage of the Saturn V rocket, they produced 7.5 million pounds of thrust. (Author's collection.)

A ground test version of the S1-C Saturn V first-stage rocket is hoisted into the test tower at the Marshall Space Flight Center in Huntsville. On July 6, 1965, all five of the Ground Test Article's F-1 engines were successfully test fired for a duration of 90 seconds. (Author's collection.)

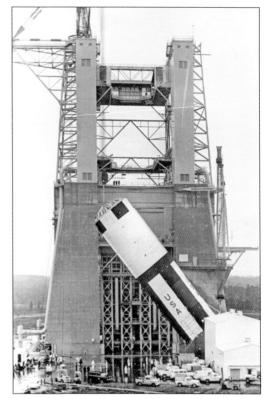

On August 25, 1967, an S1-C-5 Saturn V first stage simultaneously test fired all five of its F-1 engines successfully in the dual position B-1/B-2 Test Stand. (Courtesy of NASA.)

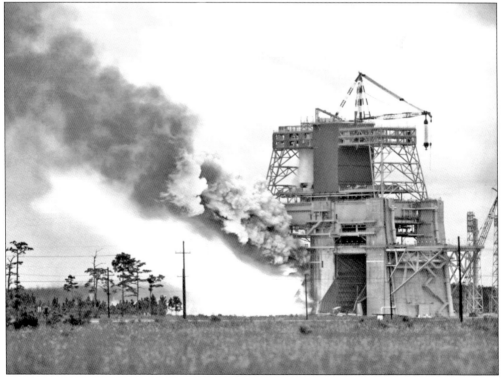

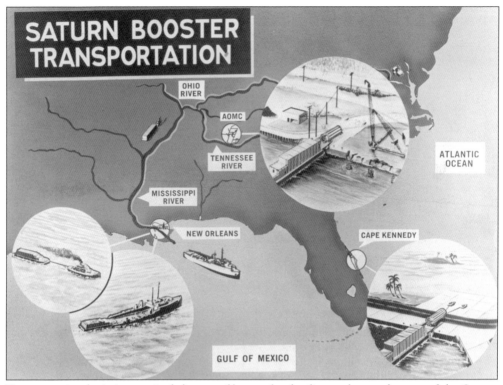

Transportation logistics required the use of barges for the first and second stages of the Saturn V. The S1-C was built at Michoud Assembly Facility in New Orleans, the S-II was assembled in Seal Beach, California, and barged through the Panama Canal. The S-IVB third stage was built by Douglas Aircraft Company, tested in California, and flown via the "Pregnant Guppy" to Cape Canaveral. (Author's collection.)

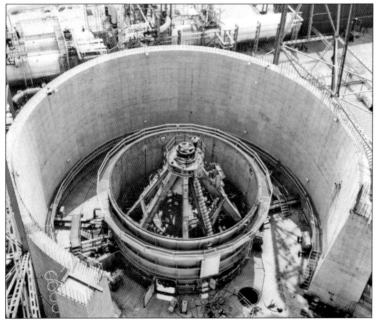

A J-2 rocket test cell is being enlarged to test the S-IVB third stage of the Saturn V rocket at Arnold Engineering Development Center on January 7, 1966. The aboveground test section (center) is being refurbished by adding two 16-by-49-foot spools, while the surrounding blast wall is heightened by 20 feet. Testing at this facility simulated altitude conditions. (Author's collection.)

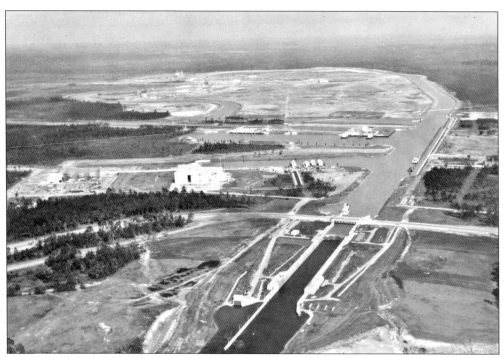

Mississippi Test Facility was in its activation phase on November 20, 1965, anticipating the start of static testing the following year. In the foreground is part of the seven-and-a-half-mile waterway with a water lock and bascule bridge leading to the propellant barge storage center. The A-2 and B-1/B-2 Test Complexes are in the background at left. The Booster Storage and Service Buildings are at left center. (Author's collection.)

By May 18, 1965, Jackson M. Balch (center) was named manager of the Mississippi Test Facility and of the MTF Activation Task Force. He is pictured here discussing the current status and tasks that lie ahead with William R. Eaton (left), general manager of General Electric's Mississippi Test Support Operation; and Hillard W. Paige, General Electric vice president of the Missile and Space Division. (Author's collection.)

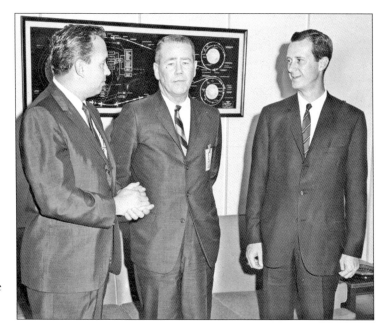

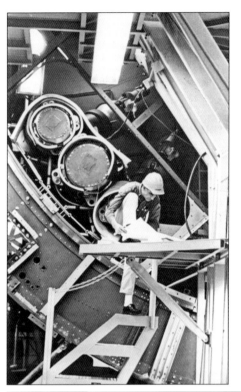

A technician studies plans for the S1-C booster of the Saturn V space vehicle under construction at Michoud Assembly Facility in New Orleans in early 1966. According to the Associated Press, "this, and other Saturn boosters, will be test fired in a huge space agency complex carved from the woods and fields near Picayune, Mississippi, known as the Mississippi Test Facility or MTF." (Author's collection.)

Peering through his car window, a NASA official views the S-II flight stage in the A-2 Test Stand as it is being prepared for testing in early February 1966. (Author's collection.)

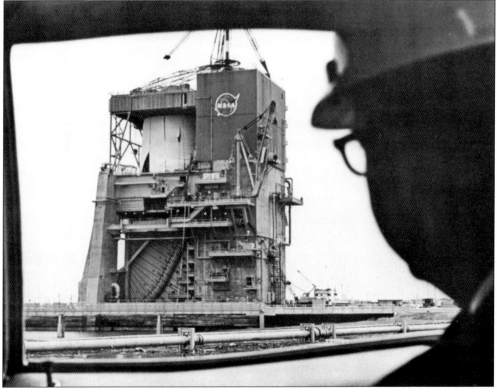

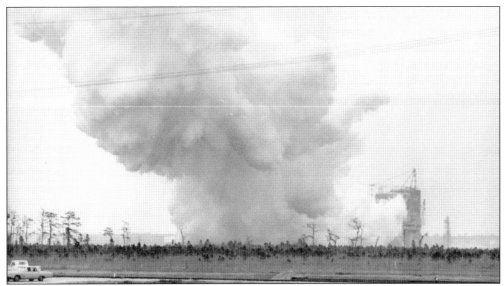

On April 23, 1966, on an overcast and misty Saturday morning at 7:27 a.m., Mississippi Test Facility became operational as the S-II-T, the Saturn V second stage prototype, was successfully captive-fired for 15 seconds. The S-II, the largest and most powerful liquid-oxygen (LOX), liquid-hydrogen (LH2) rocket stage known, developed one million pounds of thrust from its five J-2 engines. (Author's collection.)

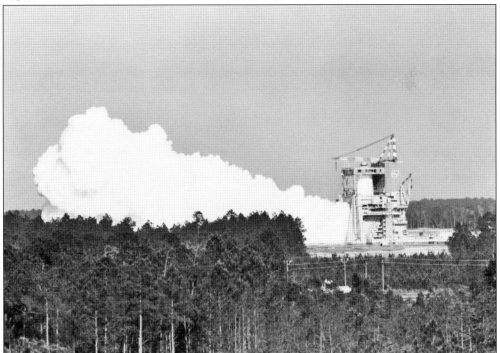

An S-II-T ("T" for "Test Article") second stage (pictured) was stopped due to a faulty helium bottle on May 10, 1966. The next day, the test was aborted after 47 seconds due to a faulty gas generator. On May 17, a successful 154-second test fire provided 1,100 measurements, gimbaling four of the five engines that provide stability and control of the rocket. (Author's collection.)

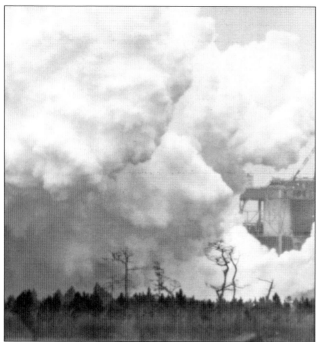

On December 30, 1966, the S-II-1 (second stage of the first Saturn V), was test fired a second time for six minutes in the A-2 Test Stand. The decision was made for post–static firing inspection and checkout to be done at Kennedy Space Center instead of MTF, remaining on schedule for a spring 1967 launch. (Author's collection.)

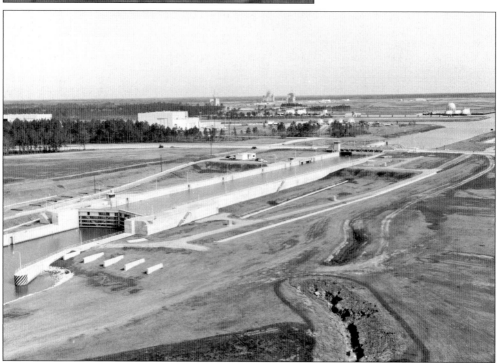

By March 1966, the construction phase at MTF was overtaken by the operational phase. From left to right are (foreground) the water locks connecting the Pearl River to the inland canal system, the bascule bridge, and propellant storage tanks; (center) Booster Storage and Service Buildings; (background) A-1 Test Stand under construction, A-2 Test Stand, and B-1/B-2 Test Stand. (Author's collection.)

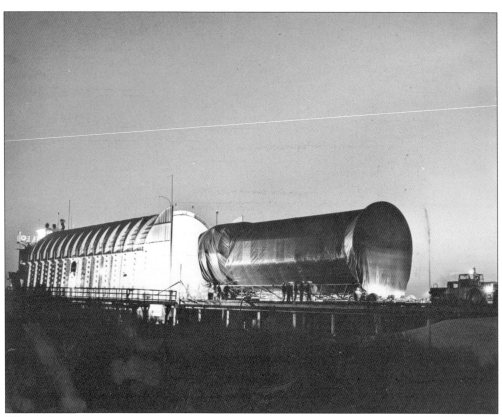

Wrapped in a protective covering developed especially for transport of the Chrysler Corporation's S1B booster rocket, this particular S1B is being loaded onto the NASA barge *Palaemon* for its river journey from Michoud Assembly Facility in New Orleans to Marshall Space Flight Center in Huntsville for testing in early 1966. The covering protected the booster during transport between the assembly, testing, and launching facilities. (Author's collection.)

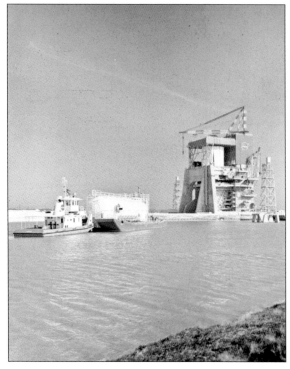

On a sunny spring day, the NASA tugboat *Clermont* pushes a cryogenics barge to the A-2 Test Complex for a test fire of an S-II second stage of the Saturn V space vehicle in May 1966. The S-II is already in position in the test stand. (Author's collection.)

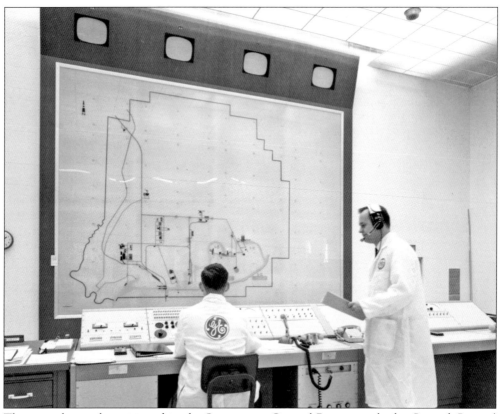

The central console positioned in the Supervisory Control Room, inside the Central Control Building (Building 1200), sported a 20-foot-wide by 24-foot-high plexiglass graphic panel with lighted displays of all systems online: left side for buildings, right side for canal and locks. General Electric, a NASA contractor, monitored the complex systems and facilities via closed-circuit television, electronic displays, radio, and visual observations. (Courtesy of NASA.)

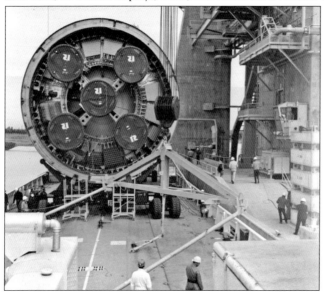

The S-II second stage of the Saturn V space vehicle arrives by barge, and its aft lifting points are about to be attached to the lifting system's spreader truss (foreground) of the A-2 Test Stand on February 21, 1967. (Author's collection.)

The S-II second stage of the Saturn V is lifted simultaneously by the A-2 Test Stand's side and top crane for transition from a horizontal to a vertical position. The hoisting lines of the top crane are attached to the forward lifting point of the S-II, enabling the transition. The top crane placed the S-II stage in its final position on February 21, 1967. (Author's collection.)

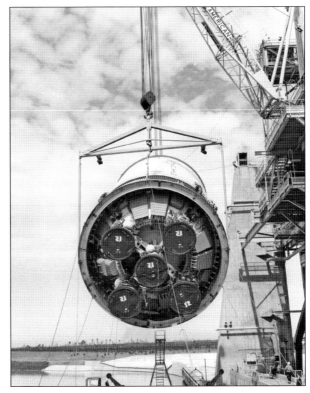

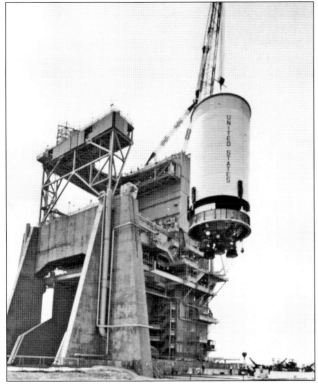

The S-II-3 flight version of the Saturn V is being lifted by its forward lifting point to be placed into the newly completed A-1 Test Stand on July 29, 1967. Its transport barge is visible in the extreme lower right. The static firing was scheduled for early September and was the first test fire using the A-1 Test Stand Complex. (Author's collection.)

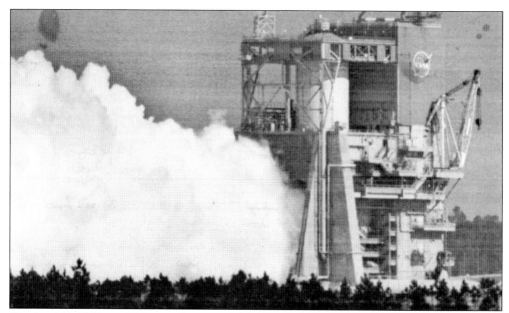

On April 7, 1967, an S-II second stage of the Saturn V (its mission number not identified) underwent a full-duration test firing on the A-2 Test Stand, producing a giant water vapor cloud from the flame deflector of the test stand. The test stand's side crane is clearly visible. (Author's collection.)

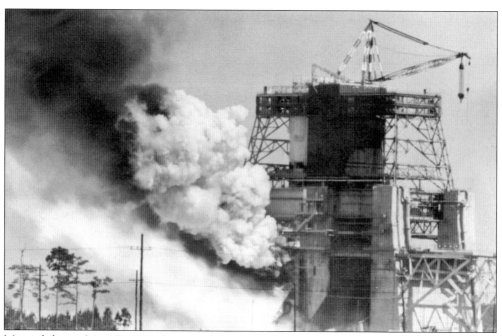

Meanwhile, on May 17, 1967, the powerful S-1C-4, first stage of the Saturn V space vehicle, is static test fired on the dual-position B-1/B-2 Test Stand Complex. (Author's collection.)

On September 28, 1967, the S-II-3, which had been placed into the A-1 Test Stand on July 29, 1967, underwent a full-duration static test fire, producing a trail of water vapor from the 200-foot-tall test stand. (Author's collection.)

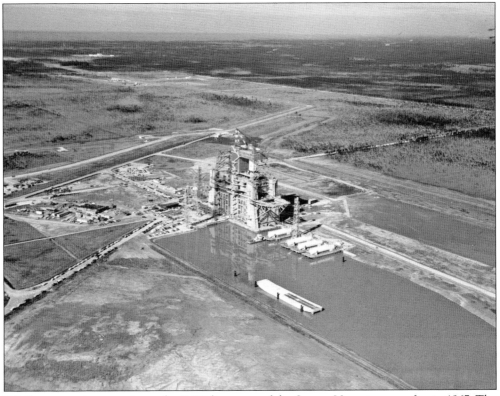

While preparations continue, the S-1C first stage of the Saturn V awaits a test fire in 1967. The engines of the S-1C, the "workhorse" of space, produce the equivalent of 160 million horsepower. It boosts the 3,164-ton Saturn V vehicle from a dead standstill on the launch pad to a height of 40 miles at 6,000 miles per hour in two and a half minutes. (Author's collection.)

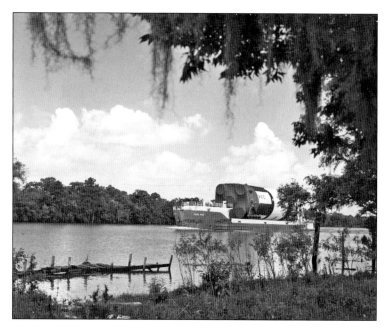

The NASA barge *Pearl River* cruises the Pearl River in southwest Mississippi, delivering an S-1C booster rocket to Kennedy Space Center for launch in 1967. The US Army Transportation Corps transferred 20 surplus barges to NASA. By March 6, 1963, eight all-steel, standard 120-foot-long, sea-going barges were sent to the US Army facility at New Orleans to transfer supplies. (Courtesy of NASA.)

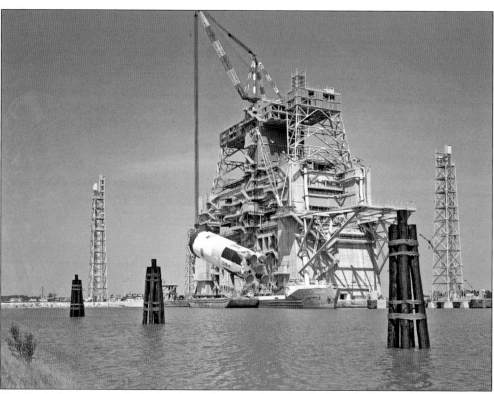

The *Pearl River* remains docked at the B-1/B-2 Test Stand as the S-1C booster rocket is lifted into place by the top crane hoisting lines attached to the booster's forward lifting point, while the side crane hoisting lines remain attached to the booster's aft lifting points, transitioning from a horizontal to a vertical position. (Courtesy of NASA.)

The S-1C-5 stage of the Saturn V is lifted vertically by the top crane of the B-1/B-2 Test Stand. Its aft section is stabilized by guidelines and manpower on its way up for placement into the test stand. The S-1C is 138 feet long, 33 feet in diameter, 150 tons empty, and constructed of aluminum alloy with four fixed fins for directional stability. (Courtesy of NASA.)

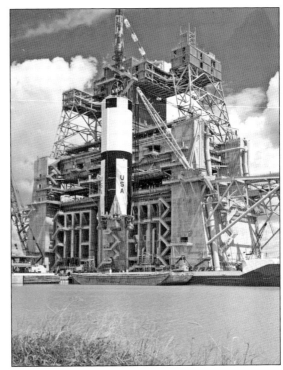

On April 26, 1967, (from left to right) Jackson M. Balch, director of Mississippi Test Facility; Dr. George Constan, director of Michoud Assembly Facility; and Charles W. Guy, board member of the Missiles and Astronautics Division of the American Ordnance Association attended a meeting of the association at the Monteleone Hotel in New Orleans. A discussion of the Saturn booster projects provided a moment of levity ahead of NASA's busiest year, 1968. (Author's collection.)

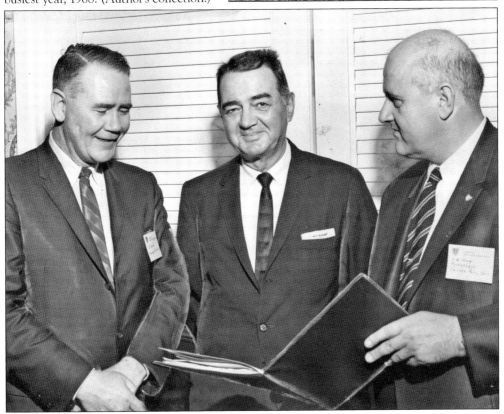

Dr. Brendan F. Brown (far left), professor of law at Loyola University, welcomed panelists to the 1967 Natural Law Institute in New Orleans. From left to right are Brig. Gen. Martin Menter, US Air Force Judge Advocate General's Corps, Air Defense Command; Matthew J. Corrigan, chairman, Interplanetary Space Law Committee; Georgiy F. Kalinin, the United Nations Committee for the Peaceful Uses of Outer Space; and Edwin R. Ling, chief counsel for NASA Michoud Assembly Facility and Mississippi Test Facility. (Author's collection.)

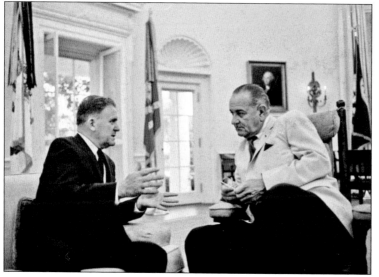

Pres. Lyndon B. Johnson (right) listens intently as NASA administrator James Webb (left) discusses the continuing progress of the Apollo/Saturn program while seated in the Oval Office on July 14, 1967. (Courtesy of the Lyndon B. Johnson Presidential Library; photo by Yoichi Okamoto.)

During a visit to Marshall Space Flight Center in Huntsville on May 22, 1967, Vice Pres. Hubert H. Humphrey (right) was given a detailed, instructional tour of the S-1C rocket booster and its F-1 engines by its director, Dr. Wernher von Braun, whose personal motto was "Early to bed, early to rise, work like hell, and advertise." (Courtesy of NASA.)

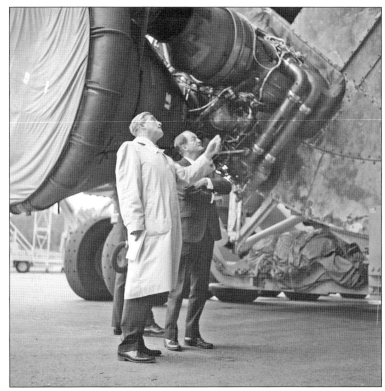

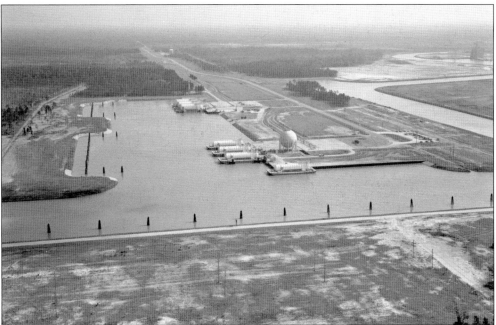

Pictured in 1967, the cryogenic storage basin, a spur off the main canal at the Mississippi Test Facility, accommodates the LH2 and LOX tanks that have been mounted on barges for fueling the S-1C and S-II, first and second stage rocket boosters, for static testing at the nearby A-1, A-2, and B-1/B-2 Test Stands. (Author's collection.)

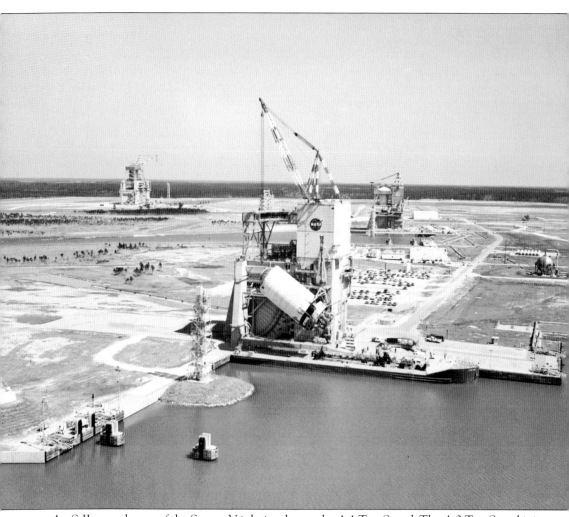

An S-II second stage of the Saturn V is hoisted onto the A-1 Test Stand. The A-2 Test Stand is in the middle distance at right, and the dual position B-1/B-2 Test Stand is in the left background. The S-II used LH2 and LOX: 97 percent of its weight was propellant, separated by a lightweight structure that saved 3.9 tons in weight. (Author's collection.)

This illustration depicts the path to the Moon and back. At launch, the SI-C ascends at 6,000 miles per hour for two and a half minutes before being jettisoned; the S-II ignites at 16,500 miles per hour and an altitude of 114 miles, and is then discarded. The S-IVB third stage is fired for 11 minutes, 39 seconds to attain Earth orbit, and is restarted two and a half hours later, pushing the Apollo spacecraft toward the Moon. (Author's collection.)

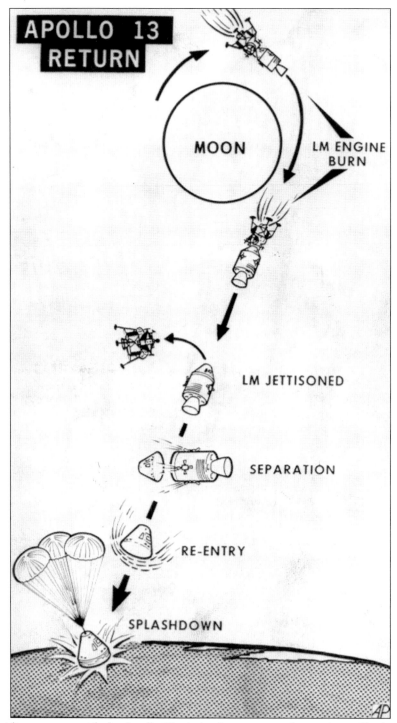

The overriding concern with the Apollo 13 mission became one of returning to Earth safely. The lunar module provided thrust to place itself and the command module on target for Earth. The lunar module was then jettisoned and the command module separated from the service module for reentry to Earth atmosphere and splashdown. (Author's collection.)

Four

BROADENING THE MISSION, RESIDENT AGENCIES
1970–PRESENT

The Mississippi Test Operations (later renamed Mississippi Test Facility, or MTF) began performing static tests on April 23, 1966, after three years of construction at the site. The first full-duration captive rocket firing was successfully completed on February 10, 1968, inaugurating the busiest year to date. During this time, the progression of unmanned and manned flights continued, reaching the ultimate objective of landing men on the Moon on July 20, 1969, and returning them safely to Earth.

In less than one month, on August 17, 1969, Hurricane Camille slammed into the Mississippi Gulf Coast between Bay St. Louis and Pass Christian with top winds of 190 miles per hour, and a 20–25 foot storm surge. Twelve days later, the third NASA administrator, Dr. Thomas O. Paine, NASA director Dr. Wernher von Braun, and Sen. John C. Stennis visited the facility to assess the situation and assure the employees of continued employment.

But on January 20, 1970, NASA announced the phase-out of MTF by the end of the year. The announcement brought swift political responses from the four senators representing Mississippi and Louisiana, who insisted that full utilization be the ultimate goal.

Copies of a study by General Electric titled "A Proposal for the Future Utilization of the Mississippi Test Facility," with an emphasis on thinking differently, were sent to 30 different federal agencies and departments on March 10, 1970. On May 19, Senator Stennis requested from NASA a list of actions taken and personnel working on the problem.

Finally, Sen. Allen J. Ellender (Democrat-Louisiana) drafted a letter dated July 9, 1970, and jointly signed by three other Democratic senators: John C. Stennis and James O. Eastland of Mississippi, and Russell B. Long of Louisiana. It was directed to the president, and expressed dismay that no effective result had yet been observed.

The same day, the president announced that NASA would not only keep MTF open but also locate the US Coast Guard's new National Data Buoy Project and a new Earth Sciences Laboratory on the site.

Aboard the USS *Hornet* on July 24, 1969, near Hawaii, NASA administrator Dr. Thomas O. Paine (left) and Pres. Richard M. Nixon watch as Apollo 11 astronauts Neil A. Armstrong, Buzz Aldrin, and Michael Collins walk from the recovery helicopter to the Mobile Quarantine Facility after their historic eight-day mission to the Moon. (Courtesy of NASA.)

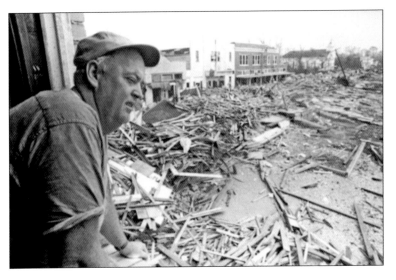

An unidentified man looks over the destruction of the main business district of Pass Christian the day after Hurricane Camille made landfall between Pass Christian and nearby Bay St. Louis on August 17, 1969. (Courtesy of the *New York Times*.)

Pictured are the remains of the 167-year-old "Pirate House" after Hurricane Camille swept ashore on August 17, 1969. The house was rumored to be a Gulf Coast shelter for pirates such as Jean Lafitte while en route to his hideout in the bayous of nearby Barataria, Louisiana. (Courtesy of the Hubbard Hurricane Camille Photographs, McCain Library and Archives, University of Southern Mississippi, Hattiesburg.)

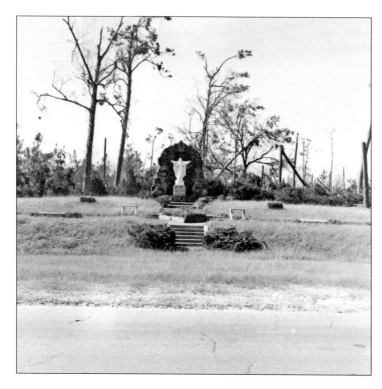

Only the steps to a shrine on Highway 90 along the Mississippi Gulf Coast survived the estimated sustained winds of 175 miles per hour and 24-foot storm surge. All measuring instruments were destroyed; the height of the storm surge was based on the high water marks inside the three remaining buildings in Pass Christian. (Courtesy of the Hubbard Hurricane Camille Photographs, McCain Library and Archives, University of Southern Mississippi, Hattiesburg.)

Senator Stennis insisted that activity at the Mississippi Test Facility continue at a high level but with other federal agencies relocating to the site, eventually becoming a multiagency center. Senator Stennis had expressed concern about the future of MTF as early as 1966. (Courtesy of US Senate Historical Office.)

Jackson M. Balch, the Mississippi Test Operations (MTO) manager, began to contact a variety of government, industrial, and educational officials after Hurricane Camille struck. Known for his use of maverick management techniques, Balch, who had served as an aide to Gen. Douglas McArthur during World War II, was a colonel in the Alabama National Guard and a technical assistant to Dr. Wernher von Braun. (Courtesy of NASA.)

Sen. James O. Eastland (Democrat-Mississippi) was one of four politically powerful senators who threatened to diminish his support of overall funding for NASA if the Mississippi Test Facility was mothballed due to Congressional budget cuts, particularly so soon after the major devastation the region suffered after Hurricane Camille. (Courtesy of US Senate Historical Office.)

Pictured is Sen. Russell B. Long (Democrat-Louisiana), whose state was home not only to NASA's Slidell Computer Complex but also to the massive Michoud Assembly Facility, where the large rockets for the Apollo program were assembled before being shipped by barge to MTF for testing. Employees at both facilities had been affected personally by Hurricane Camille. (Courtesy of US Senate Historical Office.)

Sen. Allen J. Ellender (Democrat-Louisiana) sent a letter signed by Senators Stennis, Eastland, Long, and himself to the White House, but addressed to presidential assistant Bryce Harlow, on July 9, 1970. They expressed regret that no effective action had been observed; that same day, NASA agreed to keep both facilities open and allowed the new National Data Buoy Project to be located at MTF. (Courtesy of US Senate Historical Office.)

Glade Woods (left), field manager for the Barbados Oceanographic and Meteorological Experiment (BOMEX), and Wayne Masters, of General Electric, examine the Data Acquisition System GE designed specifically for BOMEX at MTF in 1969. BOMEX was the most intensive scientific investigation over a large ocean area (the Atlantic) ever undertaken. It was the start of the development of multiagencies at MTF. (Courtesy of NASA.)

Standing atop the B-1/B-2 Test Stand after Hurricane Camille are (from left to right) future Apollo 16 commander John Young, future Apollo 16 lunar module pilot Charles Duke, and current deputy manager Henry F. Auter. The astronauts were on a morale-boosting mission when they visited MTF on September 16, 1969. (Courtesy of NASA.)

After being briefed about the plight of the surrounding area high atop the B-1/B-2 Test Stand and the proposed phase-out of the Mississippi Test Facility, astronaut Charles Duke addressed a small crowd of employees in the lobby of the Administration Building at MTF while astronaut John Young (left) stands by his side on September 16, 1969. (Author's collection.)

Standing before a mighty F-1 engine at MTF, manager Jackson M. Balch (left) discusses the importance of using the MTF site as a pilot area for environmental studies with Donald J. Whittinghill (center), science advisor to Louisiana governor John J. McKeithen and Dr. Edsel E. Thrash (right), executive director of the Mississippi Institutions of Higher Learning Board of Trustees, on March 18, 1970. (Author's collection.)

As negotiations continued in an effort to keep the Mississippi Test Facility open and viable, (from left to right) E.W. King, head of the MTF Site Operations Office, and manager Jackson M. Balch enjoy a moment of levity with Sen. John C. Stennis during the senator's visit on June 27, 1970. (Courtesy of the Congressional and Political Research Center, John C. Stennis Papers, Mississippi State University Libraries.)

The first federal agency to join NASA at the Mississippi Test Facility was the US Coast Guard's Data Buoy Project in 1970. Capt. Peter Morrill, manager (at the podium), was joined by (from left to right) Henry Auter, MTF deputy manager; Jackson M. Balch, MTF manager; and unidentified visiting officers of the US Coast Guard in front of Building 1100. (Courtesy of NASA.)

The "sentinels of the sea," the National Oceanic and Atmospheric Administration's (NOAA) new hurricane buoys wait for deployment from Gulfport, Mississippi. Data provided by the buoys on wind, wave, barometric pressure, and temperature help the National Hurricane Center accurately determine the formation or dissipation, wind circulation, and center location of tropical hurricanes. Stennis Space Center has the largest concentration of oceanographers in the world. (Courtesy of NASA.)

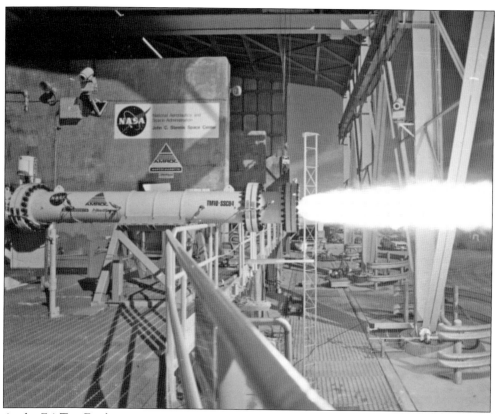

At the E-1 Test Facility in 1994, a test of a hybrid rocket motor fed by a LOX turbo pump is part of the Hybrid Technology Option Project, or HyTOP. The test was believed to be the first of its kind in the world demonstrating the low-cost development of hybrid propulsion. The HyTOP was a partnership between NASA, Martin Marietta, Amrock, Allied Signal, and Chemical System Division/United Technology Corporation. (Courtesy of NASA.)

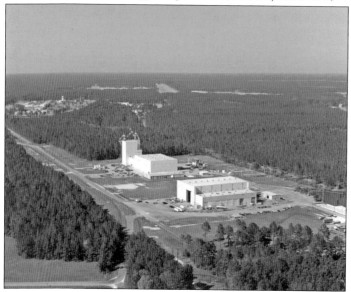

Today, at Stennis Space Center, the two buildings shown are NOAA National Data Buoy Center (left), and the National Marine Fisheries. During the Apollo program in the 1960s, the buildings served as storage areas for the first and second stages of Saturn V. (Courtesy of NASA.)

The US Navy Special Boat Team-22, Special Warfare Combatant-craft crewmen conduct exercises at SSC. The Naval Special Warfare (NSW) presence is attributable to the location of SSC with access via the Pearl River to the Gulf of Mexico, Lake Pontchartrain, and the Western Maneuver Area. SBT-22 is now the only NSW riverine unit permitting deployment to any riverine environment in the world. (Courtesy of US Navy.)

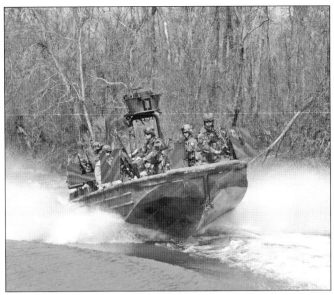

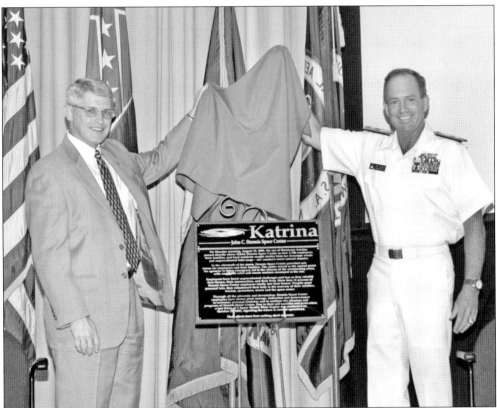

Stennis Space Center deputy director David Throckmorton (left) and Rear Adm. Timothy McGee, commander, Naval Meteorology and Oceanography Command, unveil a plaque dedicated to the unfailing discipline and courage of SSC employees, and commemorating the one-year anniversary of the arrival of Hurricane Katrina on August 29, 2005. The observance was held in the StennisSphere Auditorium, or Building 1200, on August 29, 2006. (Courtesy of NASA.)

The new Emergency Operations Center opened on June 2, 2009, supporting storm emergency responder teams and emergency management operations, as well as fire, medical, and security teams. From left to right are Steven Cooper (National Weather Service Southern Region), Tom Luedtke (NASA), Charles Scales (NASA), Mississippi governor Haley Barbour, Gene Goldman (director of SSC), Jack Forsythe (NASA), Dr. Richard Williams (NASA), and Weldon Starks (Starkes Contracting Co.). (Courtesy of NASA.)

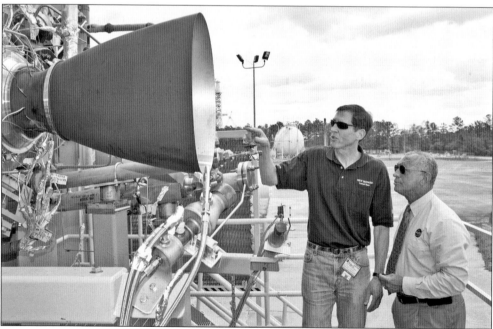

NASA administrator Charles Bolden (right) discusses the upcoming testing of Blue Origin's BE-3 engine thrust chamber assembly with Steve Knowles, Blue Origin project manager, at the E-1 Test Stand during an April 20, 2012, visit to Stennis Space Center. Blue Origin, owned by Amazon.com founder Jeff Bezos, is a NASA partner developing innovative systems to reach low-Earth orbit (LEO), and contributing to the SSC mission of quality rocket testing in a scientific setting. (Courtesy of NASA.)

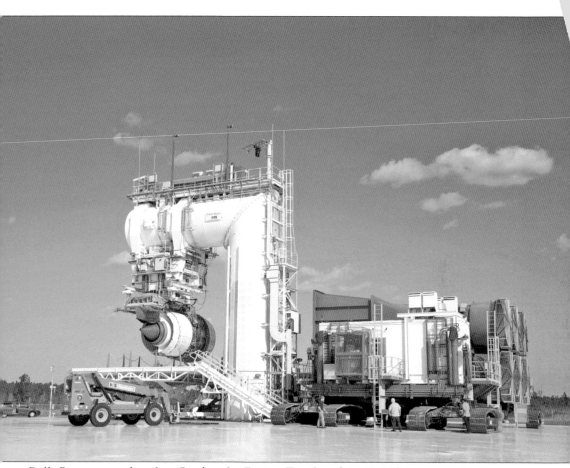

Rolls-Royce opened its first Outdoor Jet Engine Test Stand in 2007. On January 5, 2012, test preparations are underway for the XWB-84 engine used by the Airbus 350XWB. On October 16, 2013, a second test stand was placed into operation for the Trent 1000 engine, the power behind the Boeing 787 Dreamliner. Both stands comprise the Rolls-Royce Outdoor Jet Engine Test Facility at Stennis Space Center. (Courtesy of Rolls-Royce Civil Aerospace.)

In 2011, Stennis Space Center celebrated 50 years of hosting a diverse assemblage of resident agencies such as the Departments of Defense, Energy, Commerce, and Interior; the Environmental Protection Agency; the States of Mississippi and Louisiana; Mississippi State University and the University of Southern Mississippi College of Science and Technology; and major contractors such as Lockheed Martin, Pratt & Whitney Rocketdyne, and Science Applications International Corporation. (Courtesy of NASA.)

Five

SPACE TRANSPORTATION SYSTEM (STS)

1975–2011

The space shuttle era brought diverse changes to the Mississippi Test Facility: continued support of the Apollo program until its last year in 1974, transition to the Skylab program that ended in 1979, and a new, reusable space launch vehicle.

The space shuttle inaugurated an era of sustained science and space exploration, as opposed to an international race to the Moon. NASA's emphasis on both science and space exploration complemented the newly expanded goals of MTF: to ultimately serve as a base for scientific inquiry on Earth while performing the required testing for scientific inquiry in space.

A space shuttle, or "truck," that would deliver humans and cargo to a space station by means of a three-component stack—one disposable (the external tank) and the other two reusable (the orbiter and solid rocket boosters, or SRBs)—would make space travel routine and cost-effective.

One year after MTF became the National Science and Technology Laboratories, the first space shuttle main engine test bed firing, a full-thrust test of a proof-of-concept engine, was successfully completed on June 23, 1975. The space shuttle main engine (SSME) is the world's only reusable, liquid-fuel cryogenic rocket engine. NSTL tested all SSMEs throughout the Space Shuttle program, becoming NASA's primary center for testing and proving flight-worthy rocket propulsion systems.

On May 20, 1988, Pres. Ronald Reagan ordered the NSTL to be renamed Stennis Space Center in honor of its most ardent supporter, Sen. John C. Stennis. SSC became one of 10 NASA field centers, serving as NASA's program manager for rocket propulsion testing with total responsibility for conducting and/or managing all NASA propulsion test programs.

Meanwhile, under guidance provided by the Earth Science Applications Directorate at Stennis Space Center, SSC evolved into a multiagency, multidisciplinary center for federal, state, academic, and private organizations engaged in space, oceans, and environmental programs, as well as national defense. Each work side by side and share common costs related to infrastructure, facility, and technical services, using economy of scale to achieve cost benefits for their independent missions.

At a news conference at Johnson Space Center on February 25, 1976, the Approach and Landing Test Crew (ALT) demonstrate how the orbiter *Enterprise*, with its engines covered by a fairing, would use a Boeing 747 as its launch vehicle to test its flight characteristics. From left to right are Fred Haise, commander; Charles Fullerton, pilot; Joe Engle, commander; and Richard Truly, pilot. The ALT program ran from February through October 1977. (Author's collection.)

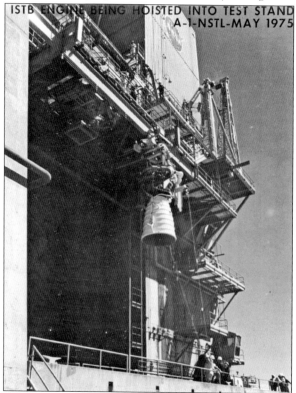

An Integrated Subsystem Test Bed, or ISTB, is hoisted into the A-1 Test Stand in May 1975. The ISTB was a tool to develop the engine start sequence and the engine shutdown sequence. This first full-up ignition test, a major milestone, was conducted on June 23, 1975, on schedule, at the National Science and Technology Laboratories. (Author's collection.)

The Integrated Subsystem Test Bed, or proof-of-concept engine, was captive fired 11 months after the Mississippi Test Operations became the National Space Technology Laboratories. A captive audience watches, from a safe distance, the first static test firing of the SSME on the A-1 Test Stand on May 19, 1975. (Courtesy of NASA.)

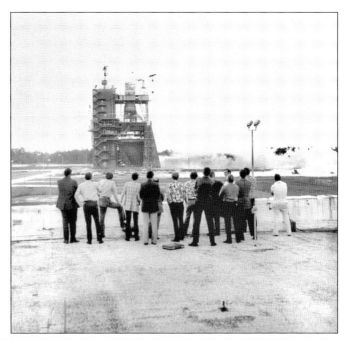

Senator Stennis barely contains his excitement after watching a successful test fire of an SSME in the A-1 Test Stand on October 19, 1978. Accompanying the senator are (from left to right) Jerry Hlass, director of the National Space Technology Laboratories; Stennis; Howard Griggs, NSTL engine test director; and Robert Bush, NSTL test program manager. (Courtesy of NASA.)

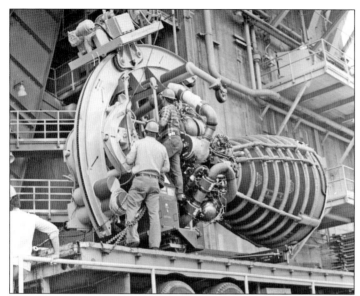

An SSME is lifted off its transporter and joined to a crane attached to the A-2 Test Stand before being hoisted into place to undergo test firing at the National Science and Technology Laboratories in 1979. (Courtesy of NASA.)

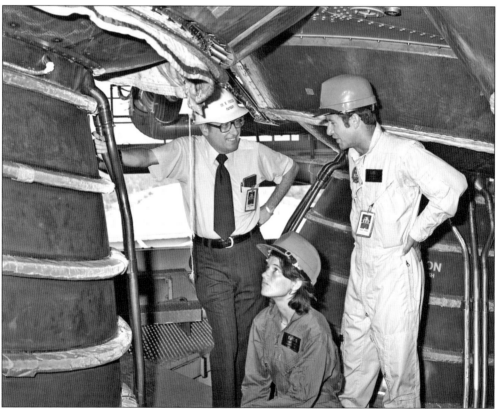

During a June 1, 1979, visit to NSTL, astronaut candidates Sally Ride and Terry Hart, along with Dr. Robert Frosch, NASA's fifth administrator, get a close look at the SSMEs on the Main Propulsion Test Article, or MPTA. Ride was the first American woman to fly in space, aboard STS-7 on June 18, 1983; Hart was a mission specialist for STS-41C on April 6, 1984. (Courtesy of NASA.)

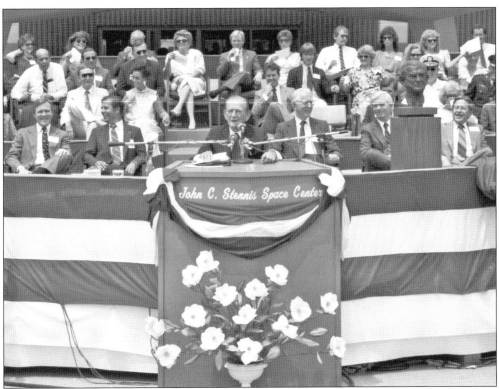

Senator Stennis strikes a humorous note during a ceremony to rename the National Space Technology Laboratories the John C. Stennis Space Center on August 3, 1988. From left to right are Gov. Ray Mabus; Jerry Hlass, director, SSC; Stennis; Dr. James Fletcher, NASA administrator; Sen. Thad Cochran (Republican-Mississippi); and Roy Estess, deputy director, SSC. (Courtesy of NASA.)

The Air Products Plant in New Orleans delivered LH2, a propellant, via barge to storage facilities at NSTL. The external tank (ET), the expendable component of the space shuttle launch vehicle, used LH2 and LOX to fuel the three SSMEs during liftoff and ascent. (Author's collection.)

An engineer examines the systems on a LOX barge docked at the Stennis Space Center's SSME test complex in 1979. The liquid propellants (LH2 and LOX) that feed the SSMEs are pumped from the barges to the test stands just prior to test firings. The barges deliver their cargo via SSC's canal system. (Courtesy of NASA.)

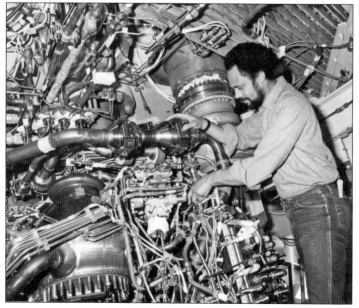

After every mission, each SSME is removed and inspected, and components are replaced if necessary. The life of an engine varies, as does the life of its components. Here, an unidentified technician performs maintenance on an SSME in 1989 prior to the next scheduled mission. (Courtesy of NASA.)

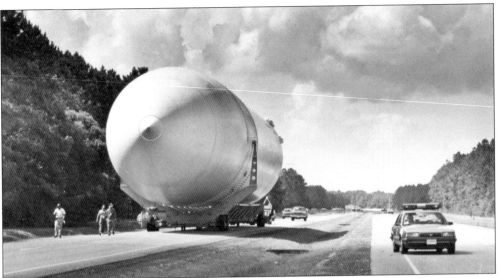

The Ground Vibration Test Article (GVTA) arrived via barge from Marshall Space Flight Center in Huntsville to Hancock County, Mississippi, where it was escorted to its new home at the John C. Stennis Space Center's new visitor center on July 10, 1990. The GVTA was used to test and verify the response of the shuttle system. (Author's collection.)

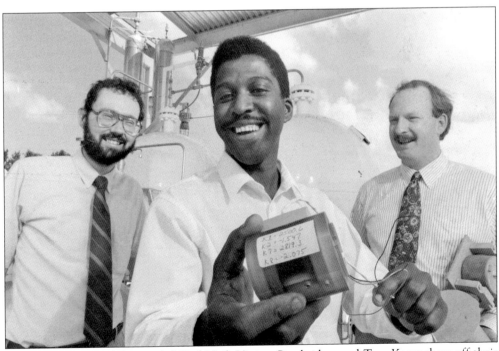

Co-inventors (from left to right) Bud Nail, Vivien Cambridge, and Tom Koger show off their Smart Hydrogen Sensor at the Cryogenic Storage Facility at Stennis Space Center on July 3, 1990. (Author's collection.)

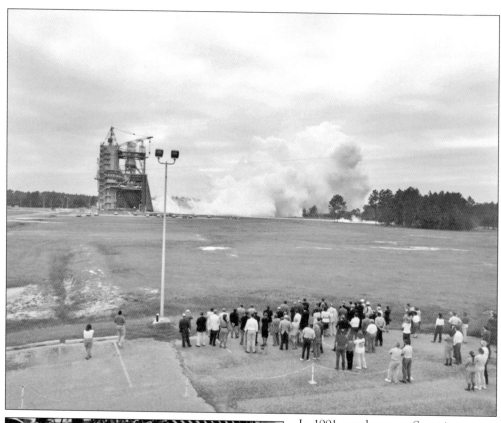

In 1991, employees at Stennis Space Center take a break from their duties to view a test firing of an SSME on the A-1 Test Stand. Test firings were almost biweekly occurrences. (Courtesy of NASA.)

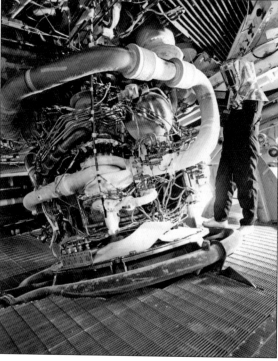

Following a relatively routine test firing, a propulsion engineer inspects an SSME and its components while it is in the test stand at SSC in 1991. (Courtesy of NASA.)

The public watches an SSME being test fired on the A-1 Test Stand (right, background), while keeping at a safe distance near the A-2 Test Stand in 1992. The sign at left reads, "Engine Test will be very noisy. Cover your ears if it becomes uncomfortable." Later, free earplugs were made available to the viewing public. (Courtesy of NASA.)

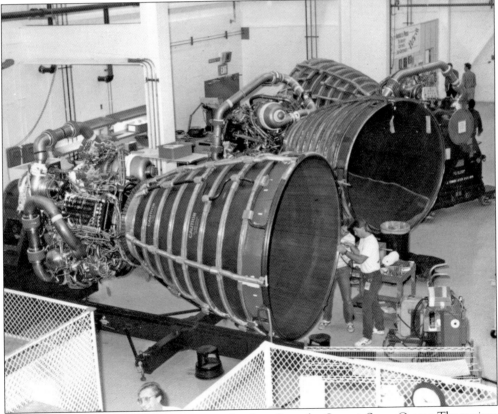

Prior to a test firing, all SSMEs were inspected and configured at Stennis Space Center. The engines were originally manufactured by Rocketdyne, of Canoga Park, California. These inspections are taking place in 1994. (Courtesy of NASA.)

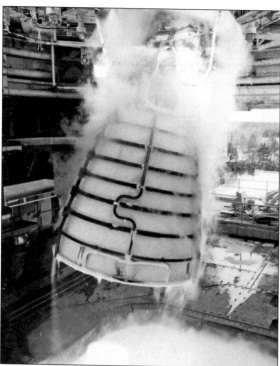

A 1995 close-up view of an SSME during a test at the Stennis Space Center demonstrates how the engine is gimbaled, or rotated, to evaluate the performance of its many components under simulated flight conditions. (Courtesy of NASA.)

A test fire is in progress on the immense B-1 Test Stand in 1996. By 1988, the Space Shuttle program required a third test position at Stennis Space Center. The B-1 position of the B-1/B-2 Test Stand was converted to accept and test the SSME. On August 20, 1990, the A-1, A-2, and B-1 Test Stands conducted tests on the same day for the first time. (Courtesy of NASA.)

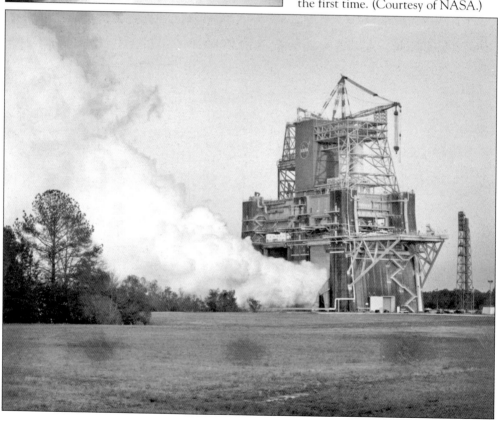

The public was routinely invited to test firings, even for this first night test on April 21, 2001, which also marked the 20th anniversary of space shuttle flights. Announcements appeared in the local newspapers as SSC began to test fire SSMEs twice weekly to certify new equipment for flight or collect data on redesigned parts still in development. (Courtesy of NASA.)

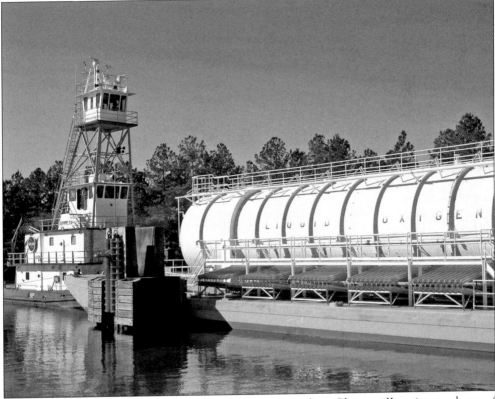

After traversing the Pearl River, the crew of the NASA tugboat *Clermont II* navigates a barge of super-cooled LOX through the seven-mile canal system at Stennis Space Center. LOX is one of two propellants (the other is LH2) used to power the SSMEs. (Courtesy of NASA.)

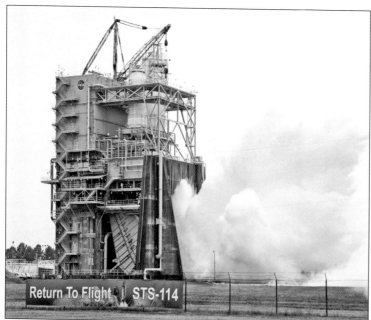

The SSME being tested is the first complete engine to be tested and shipped in its entirety to Kennedy Space Center for STS-114. On July 16, 2004, the test ran for a milestone 520 seconds (eight minutes)—the time it takes for the space shuttle to reach orbit. (Courtesy of NASA.)

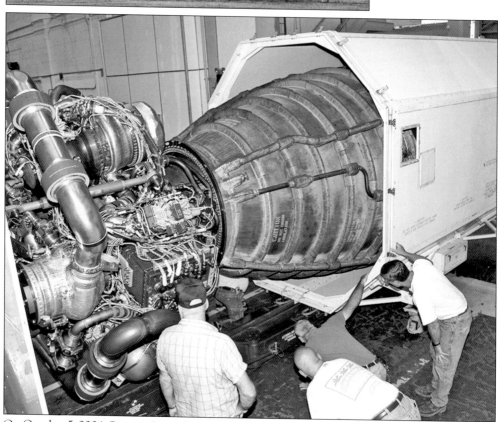

On October 5, 2004, Stennis Space Center shipped the last of the three SSMEs to Kennedy Space Center for installation on space shuttle *Discovery* for STS-114, NASA's "Return to Flight" mission following the 2003 STS-107 space shuttle *Columbia* accident. (Courtesy of NASA.)

Following Hurricane Katrina on August 28, 2005, Stennis Space Center became the site of the Federal Emergency Management Agency's Incident Command Center for a six-county area along the Mississippi Gulf Coast for almost three months. Congress passed House Resolution 948, recognizing the employees who remained there during the hurricane, protecting the critical test infrastructure, enabling it to be reopened the next day for recovery efforts. (Courtesy of NASA.)

Alvin Pittman Sr. (background), lead electronics technician; and Janine Cuevas, mechanical technician; both with Pratt & Whitney Rocketdyne, perform final preparations on the SSME that was tested October 25, 2005, at SSC, less than two months after Hurricane Katrina hit the Mississippi Gulf Coast on August 29, 2005. (Courtesy of NASA.)

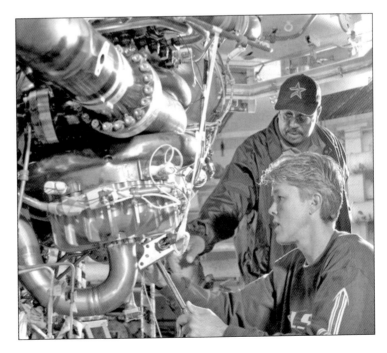

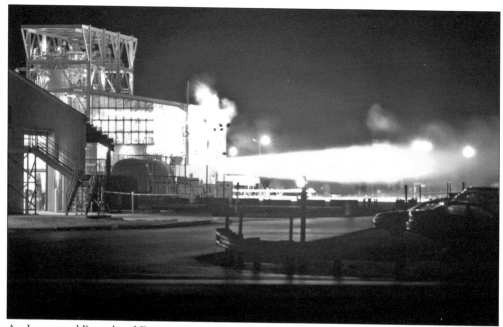

An Integrated Powerhead Demonstrator Engine (IPD) is test fired at the E Test Complex at SSC, with Wayne North as the test conductor, on December 8, 2005. The IPD is a reusable engine system that could power a return to the Moon, or travel to Mars and beyond. It is a collaboration between Pratt & Whitney Rocketdyne Aerojet under the direction of the Air Force Research Laboratory and NASA Marshall Space Flight Center. (Courtesy of NASA.)

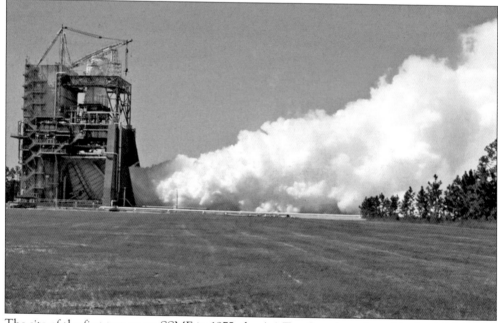

The site of the first test on an SSME in 1975, the A-1 Test Stand conducted its final SSME test for the Space Shuttle program on September 29, 2006. Stennis Space Center continued to test the SSME on its A-2 Test Stand until the end of the Space Shuttle program in 2011. The A-1 was converted to test other engines, notably the J-2X. (Courtesy of NASA.)

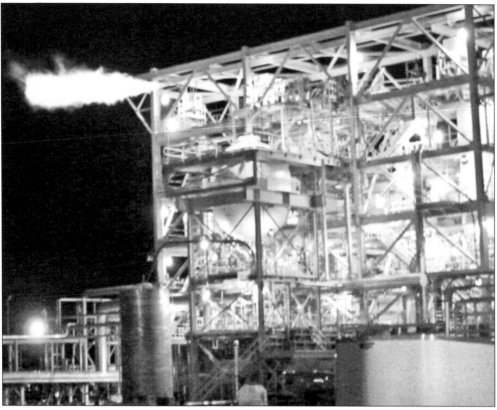

Flames burst from the E-1 Test Stand on February 12, 2009, as engineers perform one of dozens of tests on a space shuttle flow valve. Space Shuttle Mission STS-119 was delayed over concerns about the flow valve. Engineers at SSC teamed with the Innovative Partnership Program to perform the tests. (Courtesy of NASA.)

SSME No. 0525 is lifted from the A-2 Test Stand at Stennis Space Center after successfully enduring the last planned SSME test on July 29, 2009. The A-3 Test Stand (center, background), was under construction, while part of the SSC canal system appears at right. (Courtesy of NASA.)

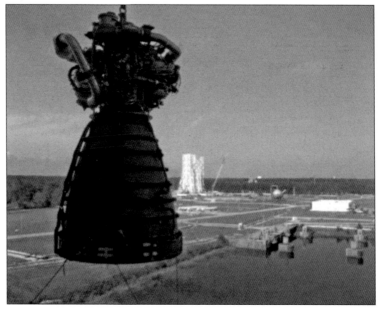

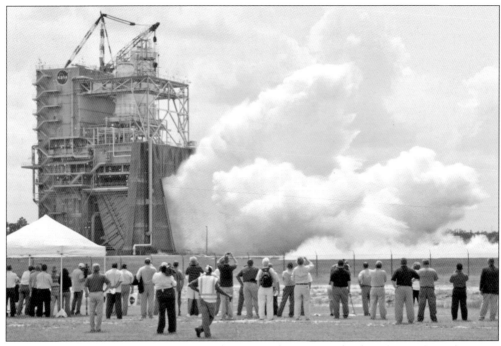

The public and Stennis Space Center employees watch 520 seconds of "shake, rattle, and roar" as the last SSME is tested on July 29, 2009, marking the end of nearly three decades of testing the engines that powered the Space Transportation System to LEO. (Courtesy of NASA.)

NASA's *Pegasus* barge serenely plies the waters of the Pearl River as it is about to enter the Stennis Space Center's seven-mile canal system to deliver SSME ground support equipment to SSC on November 16, 2011. (Courtesy of NASA.)

Stennis Space Center director Patrick Scheuermann (right, at podium) welcomes the crew members of STS-135. From left to right are commander Chris Ferguson, pilot Doug Hurley, and mission specialists Sandy Magnus and Rex Waldheim. The post-flight crew visit took place in the auditorium of Building 1200, or StenniSphere, on July 8, 2011. (Courtesy of NASA.)

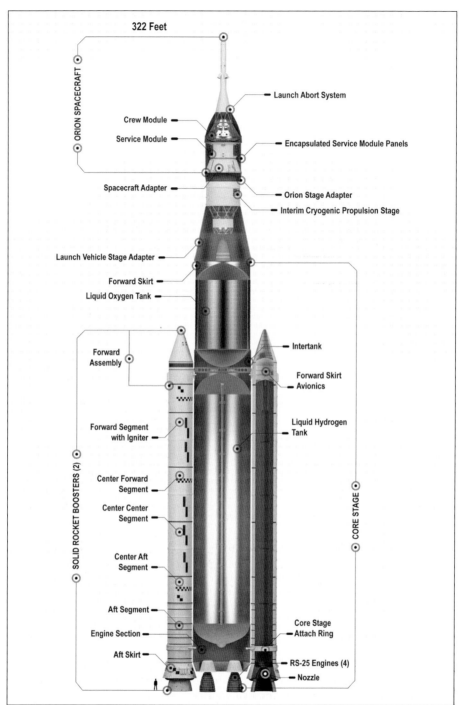

322 Feet

ORION SPACECRAFT

- Launch Abort System
- Crew Module
- Service Module
- Encapsulated Service Module Panels
- Spacecraft Adapter
- Orion Stage Adapter
- Interim Cryogenic Propulsion Stage
- Launch Vehicle Stage Adapter
- Forward Skirt
- Liquid Oxygen Tank

SOLID ROCKET BOOSTERS (2)

- Forward Assembly
- Intertank
- Forward Skirt
- Avionics
- Liquid Hydrogen Tank
- Forward Segment with Igniter
- Center Forward Segment
- Center Center Segment
- Center Aft Segment
- Aft Segment
- Engine Section
- Aft Skirt

CORE STAGE

- Core Stage Attach Ring
- RS-25 Engines (4)
- Nozzle

This cutaway diagram identifies the components of the Block 1, Exploration Mission 1 (EM1), of the Space Launch System (SLS) that will lift a payload of 77 tons, carrying an uncrewed Orion spacecraft beyond LEO to test the performance of its integrated systems. It will be followed by EM2 Block 1B Crew to a near-Earth asteroid, and then to Mars with EM2 Block 2 Cargo. (Courtesy of NASA.)

Six

SPACE LAUNCH
SYSTEM (SLS)

2012–PRESENT

In 2006, the Constellation program, which included development of a crew capsule named Orion and two types of booster vehicles, Ares I and Ares II, were deemed to be unfeasible and were cancelled in 2010. In 2011, a new Orion program was initiated that included the renamed Orion Multi-Purpose Crew Vehicle (MPCV), and work began on a new megarocket Space Launch System using space shuttle–era RS-25 engines and twin solid rocket boosters.

Accordingly, modifications were needed to the B-2 Test Stand to accommodate core stage propulsion testing at Stennis Space Center. The core stage is nearly 50 percent longer than the Saturn V S-1C stage. Structural restoration construction encompassed restoration and upgrade of the main derrick crane that sits atop the stand, replacement of fixed and movable platforms on the engine servicing deck, and restoration of the booster support frame.

The B-2 Test Stand restoration continued with mechanical/piping and high voltage electrical restoration, and the structural buildout of the stand to accommodate the size of the core stage. A new 100-foot superstructure was added for thrust takeout and access to the core stage, along with replacement of the existing tarmac at the loading dock, to accommodate barge offloading of the core stage transporter and insertion into the test stand. NASA then installed a new pump alongside existing pumps at the High-Pressure Industrial Water facility (HPIW) to supply an additional 25,000 gallons of water per minute to the stand, which will help suppress sound and lessen the vitro-acoustic impact on the core stage.

Engineers will conduct three types of tests: modal tests to assess the structural vibration modes, tanking tests to verify prelaunch sequences for pressurizing stage systems and for filling and draining propellants, and hot-fire tests that will fire four RS-25 engines simultaneously.

At Michoud Assembly Facility in New Orleans, welders perform manual weld operations inside a tank that will be part of the Space Launch System core stage. The five components of the SLS core stage are the engine section (the RS-25 engines are attached), liquid hydrogen tank, intertank (avionics and electronics), liquid oxygen tank, and the forward skirt (flight computer, cameras, and avionics). (Courtesy of NASA.)

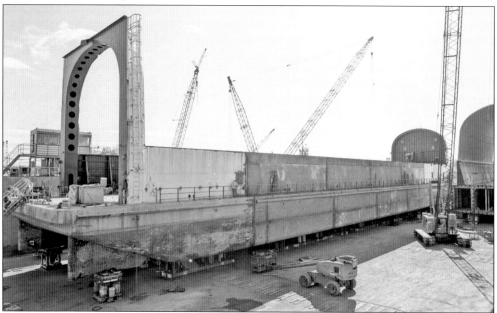

The *Pegasus* barge entered the dry dock at Conrad Shipyard of Morgan City, Louisiana, for repair, refit, and refurbishing operations in 2014. Designed and built to transport space shuttle external tanks, it was mothballed in 2011 at SSC. The barge was enlarged from 260 feet to 310 feet and qualified to carry more than 600,000 pounds. (Courtesy of NASA.)

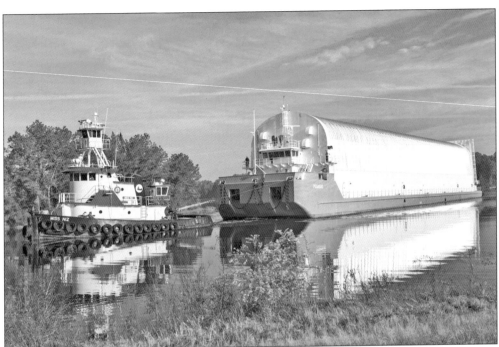

Pegasus plies the waters of the Pearl River in Mississippi on its way from Stennis Space Center to Michoud Assembly Facility. Released from dry dock in 2015, *Pegasus* met American Bureau of Shipping standards such as load line certification for its 900-mile sea journeys from Michoud to SSC and on to Kennedy Space Center, which includes both inland and open ocean waterways. (Courtesy of NASA.)

Construction is under way on Test Stand 4697, which will test the 70-foot-tall, 196,000-gallon LOX tank test article. Nearby, its twin, Test Stand 4693, at 215 feet, will subject the 537,000-gallon LH2 tank to the same stresses and pressures experienced during launch and in flight. Both test stands were completed in late 2016 at West Test Area at Marshall Space Flight Center in Huntsville. (Courtesy of NASA.)

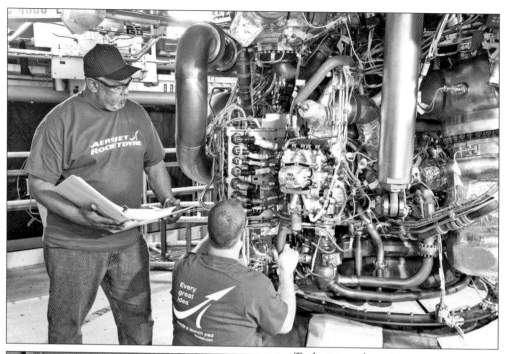

Technicians for prime contractor Aerojet Rocketdyne of Sacramento, California, inspect the new engine controller on RS-25 Development Engine No. 0528, a ground-test workhorse, at Stennis Space Center. The RS-25 controller ensures that the fuel-rich staged-combustion cycle engine turns LH2 and LOX at high temperatures and high pressures into 418,000 pounds of thrust at sea level. (Courtesy of NASA.)

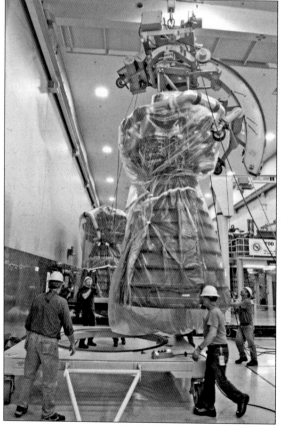

One of 16 RS-25 engines arrives at SSC from Kennedy Space Center. Of the 16 RS-25 engines, 14 are surplus engines that flew on the space shuttle, and will fly again on the core stage of the Space Launch System. The 17th engine, No. 0528, is a development engine. (Courtesy of NASA.)

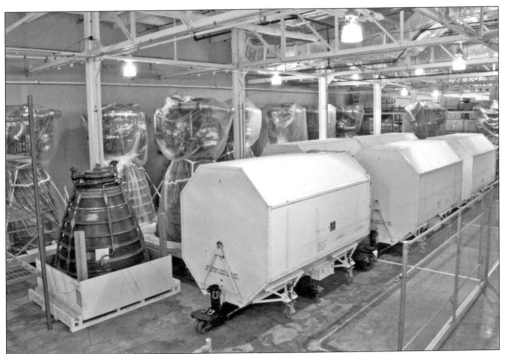

The 16 surplus RS-25 engines arrive at Stennis Space Center for storage. They have been modified to operate at a higher performance level with new engine controllers. Here, they will be carefully bagged for protection from dirt and dust in an air-conditioned warehouse. (Courtesy of NASA.)

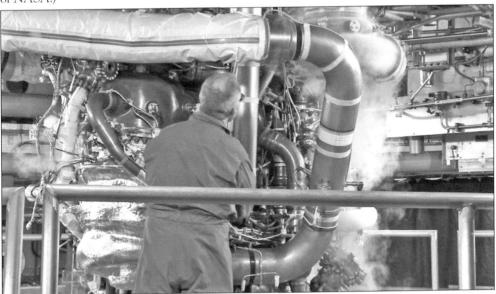

Before hot-fire testing, there first must be a chill-test on RS-25 development engine No. 0528. The RS-25 No. 0528 helped clear the way to hot-fire testing in 2015. During a chill-test, super-cold rocket propellants are flowed through stand and engine piping. Temperatures, pressures, flow rates of the propellants, the steps of the chill procedure, and the time needed to chill the pumps and engines for hot-fire tests are monitored. (Courtesy of NASA.)

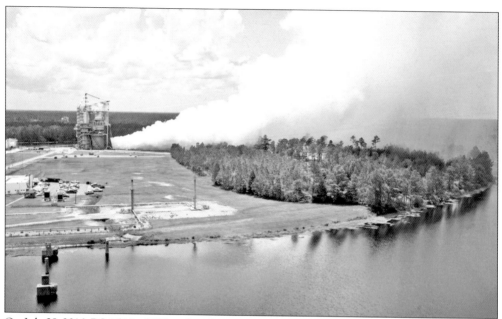

On July 29, 2016, RS-25 No. 0528 endured a successful developmental test at Stennis Space Center. These tests are focused on the new engine controller and the higher operating parameters for the SLS, such as starting at different temperatures and pressures. This test was conducted by a team of NASA, Aerojet Rocketdyne, and Syncom Space Services engineers and operators. (Courtesy of NASA.)

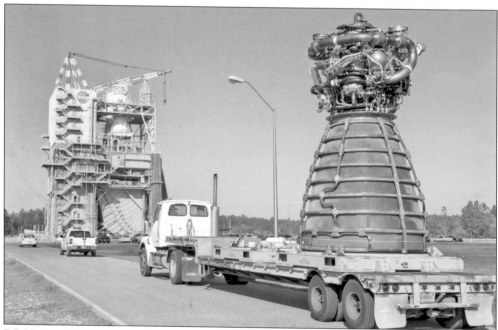

RS-25 No. 0528 arrives at the A-1 Test Stand at Stennis Space Center on November 4, 2015. A 420-second hot-fire test continued to exercise the new engine controller that will be used on the surplus engines and the expendable follow-ons. The new controller is based on a modernized controller developed for the J2X upper-stage engine upgrade for SLS. (Courtesy of NASA.)

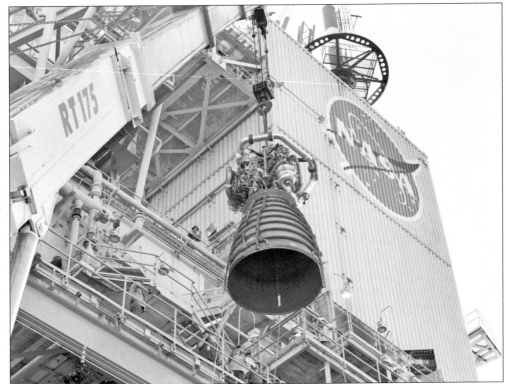

RS-25 development engine No. 0528 is hoisted onto the A-1 Test Stand at Stennis Space Center sometime in early 2016 for a subsequent test. Subsequent tests will involve installing the flight stage on the B-2 Test Stand and firing all four engines simultaneously as in an actual launch. (Courtesy of NASA.)

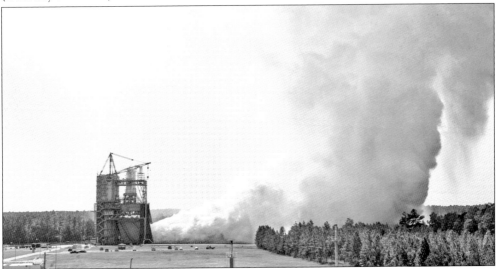

RS-25 No. 0528 fires up for a 535-second test on August 27, 2015, at Stennis Space Center. This was the final test in a series of seven tests for development engine No. 0528, which provided NASA engineers critical data on the revised engine controller unit and inlet pressure conditions. (Courtesy of NASA.)

Eric Corder (right), avionics system manager at Marshall Space Flight Center in Huntsville, discusses the SLS booster avionics system with an unidentified technician at Orbital ATK's Clearfield, Utah, laboratory. The avionics system is responsible for igniting, steering, and jettisoning the two five-segment solid rocket boosters that are attached on each side of the core stage. (Courtesy of NASA.)

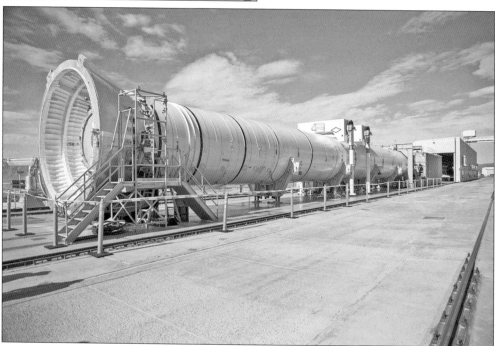

A solid rocket booster awaits the second of two qualification ground tests on June 28, 2015, at Orbital ATK's test facility in Promontory, Utah. The first test was for acceptable performance of the booster design at high temperature conditions, the second test measured a cold motor conditioning target of 40° F. Both tests demonstrate the effect of temperature range on the ballistic performance of the propellant. (Courtesy of NASA.)

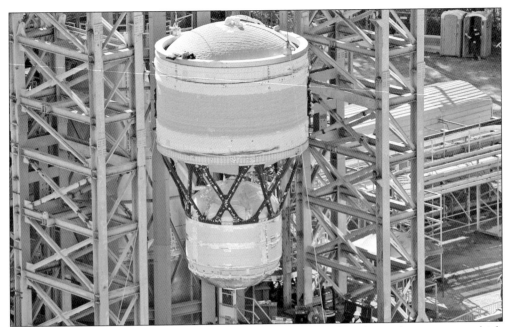

The interim cryogenic propulsion stage (ICPS) is the LOX/LH2-based propulsion stage on which the Orion Multi-Purpose Crew Vehicle system is mounted. The ICPS, using a single RL-10 engine, will give the Orion MPCV the boost, while in space, to fly beyond the Moon before it returns to Earth. (Courtesy of NASA.)

Technicians with Janicki Industries in Hamilton, Washington, position a diaphragm composed of a special composite material for Orion's spacecraft adapter stage, which joins the ICPS to the encapsulated service module panels stage, part of the Orion MPCV. The diaphragm is a composite of carbon fiber fabric ingrained with epoxy, used to keep launch vehicle gases away from the spacecraft. (Courtesy of NASA.)

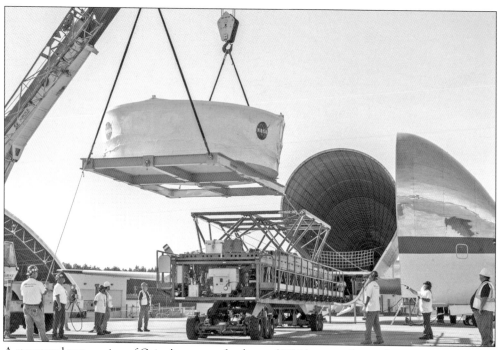

A structural test version of Orion's spacecraft adapter (OSA) stage is hoisted onto a transporter at the Redstone Arsenal Airfield in Huntsville for delivery to Lockheed-Martin in Denver, Colorado, via NASA's Super Guppy aircraft. The OSA is built by Teledyne Brown at Marshall Space Flight Center in Huntsville. (Courtesy of NASA.)

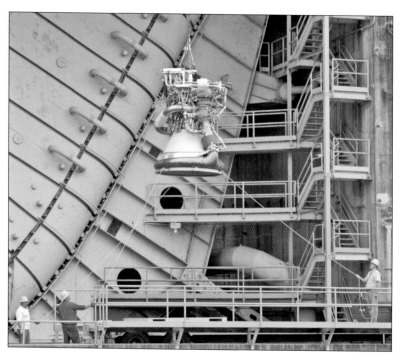

In February 2013, J-2X Engine No. 10002 was hoisted onto the A-1 Test Stand at Stennis Space Center for the second in a series of six tests. The J-2X and the A-1 Test Stand have been modified for simulated altitude testing. The J-2X E10002 is designed to start at altitude as part of a second or third stage of a large, multistage launch vehicle. (Courtesy of NASA.)

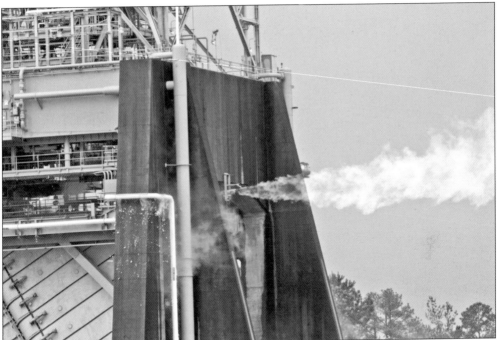

At the A-2 Test Stand at Stennis Space Center on June 8, 2012, engineers conducted a record-breaking 1,150-second test wherein the J-2X power pack was throttled up and down several times to explore numerous operating points. These test points are required for fuel and oxidizer turbopumps, which deliver high pressure propellant to the combustion chamber where they mix and burn to produce thrust. (Courtesy of NASA.)

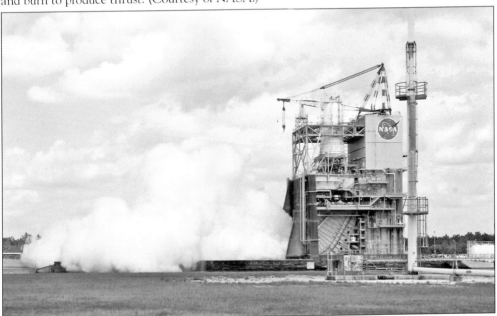

The first human-rated LOX and LH2 rocket engine to be developed in 40 years, the J-2X engine No. 10002 returns to the A-1 Test Stand at SSC for a second round of tests after both engine and test stand have been modified to begin simulated altitude testing. (Courtesy of NASA.)

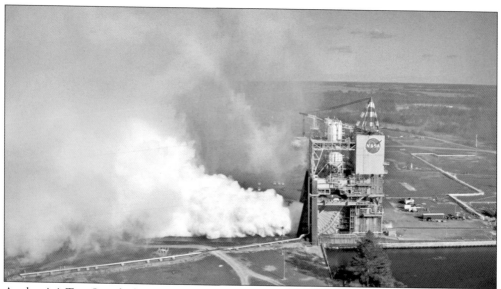

At the A-1 Test Stand, the RS-25 No. 0528 endures a developmental test for 380 seconds on February 22, 2017. (Courtesy of NASA.)

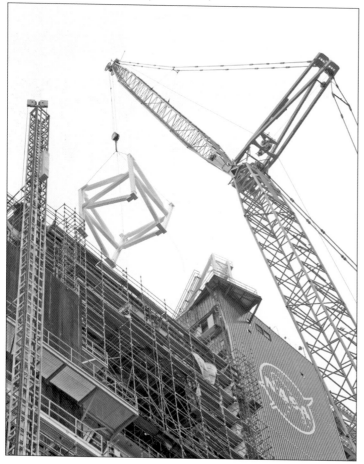

Renovation of the B-2 Test Stand continues on May 14, 2015, as structural steel is hoisted to the top for the buildout of the test stand to accommodate the core stage Main Propulsion Test Article (MPTA), which will be 50 percent longer than the Saturn stages. (Courtesy of NASA.)

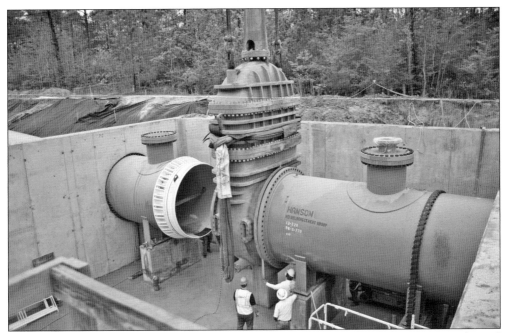

As part of the test support restoration at the B-2 Test Stand, a new high-pressure industrial water pump with a 96-inch valve was installed alongside existing pumps on March 26, 2015. The pump will supply an additional 25,000 gallons of water per minute to the test stand. (Courtesy of NASA.)

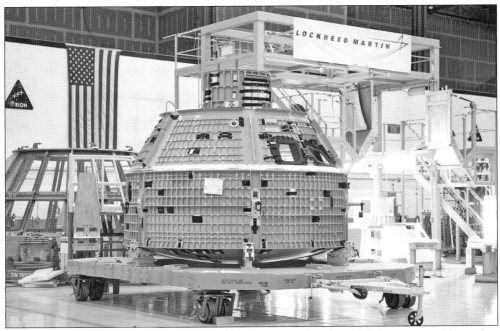

The crew module structure of the Orion MPCV is prepared to leave Michoud Assembly Facility via NASA's Super Guppy for the Neil Armstrong Operations and Checkout Building (O&C) at Kennedy Space Center. In the O&C High Bay, it will be outfitted with the systems and subsystems of final assembly and testing. (Courtesy of NASA.)

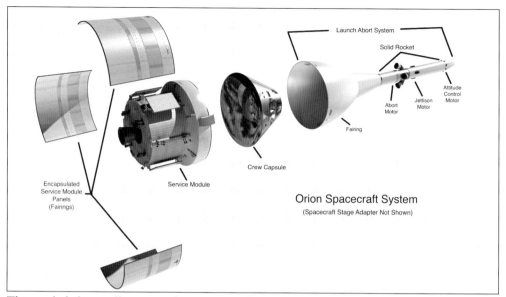

This exploded-view illustration demonstrates the complexity of protecting the crew from heat, wind, and acoustics by covering the entire crew capsule with the fairing assembly. Sitting atop the fairing assembly are three solid propellant rocket motors (left to right): the abort motor, jettison motor, and attitude control motor. The system was successfully tested in 2010 at the White Sands Missile Range near Las Cruces, New Mexico. (Courtesy of NASA.)

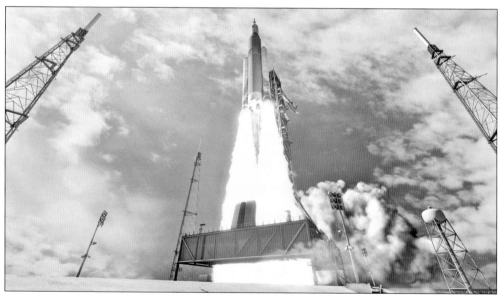

This artist's conceptual drawing depicts the Space Launch System and the Orion Multi-Purpose Crew Vehicle, slated for flight in 2019. The unmanned Exploration Mission-1 (EM-1) will demonstrate the integrated performance of the SLS and Orion MPCV. (Courtesy of NASA.)

Seven

THE HONORABLE JOHN C. STENNIS

1901–1995

The youngest son of a Presbyterian gentleman farmer of Scottish descent, John Cornelius Stennis was born in the community of Kipling, south of DeKalb in Kemper County, Mississippi. A few years later, the family moved to DeKalb, where young John attended classes in a one-room schoolhouse and began to apply the same criteria to guide his life that his father used to judge the quality of his tenant farmers: their ability to guide their mule straight while pulling a wooden-handled one-bottom plow. While developing a reputation for unyielding ethical standards, John plowed his way through the Kemper County Agricultural High School near Scooba (now East Mississippi Junior College), Mississippi A&M near Starkville (now Mississippi State University), and the University of Virginia Law School at Charlottesville, Virginia, returning to DeKalb to practice law.

Viewing public service as a "delegation of power *from* the people," Stennis served his constituency in the Mississippi House of Representatives and as district attorney for the 16th Judicial District Court, and later as circuit court judge. Turned down for military service for health reasons in 1942, he successfully ran for the US Senate in 1947, the result of a simple grass-roots campaign. Over time, he quickly became known as the "Conscience of the Senate," respected for his integrity, diligence, and judgment while serving on the Select Committee on Standards and Conduct (author of the original Senate Ethics Bill), the Committee on Armed Services, and the Committee on Appropriations.

A lifelong Democrat, Senator Stennis prized honesty and fairness when pursuing contentious issues either with Republicans or Democrats, while maintaining amicable friendships with both. In 1989, after 41 years serving *with* (not under), eight presidents, the senator retired, stating that no finer compliment could be given to him than to plainly say, "He plowed a straight furrow."

Senator Stennis posed for this formal photograph around the late 1940s or early 1950s at the studio of Harris & Ewing. Known for prescribed portraits of government figures, Harris & Ewing was a full-service photographic firm owned and operated by George W. Harris and Martha Ewing from 1905 to 1977. (Courtesy of the Congressional and Political Research Center, John C. Stennis Papers, Mississippi State University Libraries.)

Senator Stennis celebrates with his family after his swearing-in ceremony in Washington, DC, in 1947. From left to right are his daughter Margaret Jane; Stennis; his wife, Coy; and his son John Hampton. (Courtesy of Kemper County Historical Association.)

Senator Stennis liked Pres. John F. Kennedy and looked forward to working with him. Stennis often joked that Kennedy did not *ask*, but *told* him that he expected Stennis's support of the newly formed space program. (Courtesy of Kemper County Historical Association.)

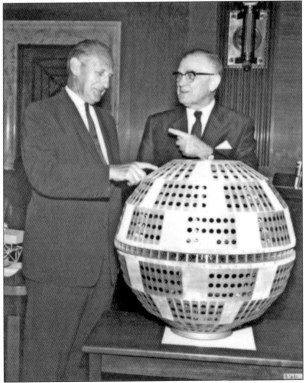

James Brown Fisk (left), president of Bell Laboratories, discusses the Telstar satellite with Senator Stennis. Telstar, launched July 12, 1962, from Cape Canaveral, Florida, was the first privately sponsored space mission and the first active communication satellite transmitting television signals until February 1963. Fisk helped organize the Office of Science and Technology during the administration of Pres. Dwight D. Eisenhower in the 1950s. (Courtesy of the Congressional and Political Research Center, John C. Stennis Papers, Mississippi State University Libraries.)

In this undated photograph, Capt. William C. Fortune (left), first site manager of Mississippi Test Operations, presents Senator Stennis with his own hard hat that will identify him during subsequent visits to the site. Senator Stennis was a regular visitor to the rapidly changing rocket testing site. (Courtesy of the Congressional and Political Research Center, John C. Stennis Papers, Mississippi State University Libraries.)

Senator Stennis (left) tours the Mississippi Test Facility accompanied by two unidentified people and E.W. "Van" King (right), who had left the Redstone Arsenal in Huntsville to head up the MTF Site Operations Office as concern over the future of MTF intensified. In the foreground is a 1960s-era oscilloscope, made by the Tektronix Company. (Courtesy of the Congressional and Political Research Center, John C. Stennis Papers, Mississippi State University Libraries.)

Admiring the unveiling of a plaque dedicated to
Adm. John S. McCain Sr. of Teoc, Mississippi,
on July 14, 1961, are Senator Stennis (left) and
Adm. John S. McCain Jr., the father of Sen. John
S. McCain III of Arizona. The ceremony marked
the opening of Naval Air Station Meridien,
McCain Field, near Meridien, Mississippi,
which sits astride both Lauderdale and Kemper
Counties. Senator Stennis's home county is
Kemper County. (Courtesy of the Congressional
and Political Research Center, John C. Stennis
Papers, Mississippi State University Libraries.)

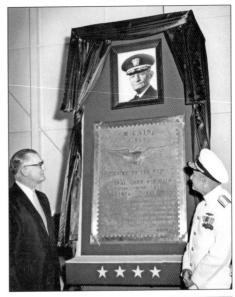

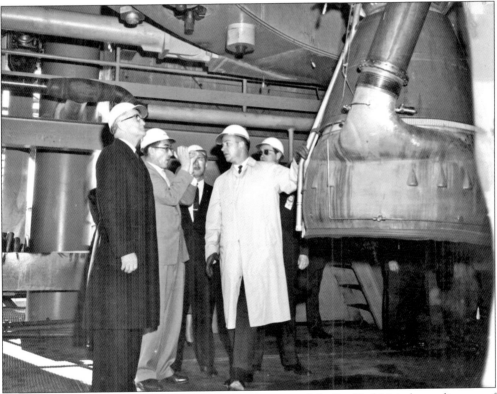

Senator Stennis (left) looks over an early H-1 engine, while Dr. Karl Heimburg, director of
the Astronautics Laboratory, standing next to Stennis, gestures during a discussion with three
unidentified NASA officials at Marshall Space Flight Center in Huntsville. This early H-1 engine
shows triangular features around the aspirator exit plane area. Eight were used on the first stages
of the Saturn 1 and Saturn 1B. (Courtesy of the Congressional and Political Research Center,
John C. Stennis Papers, Mississippi State University Libraries.)

Senator Stennis and his wife, Coy Hines Stennis, enjoy a relaxed moment together in this undated photograph. (Courtesy of Kemper County Historical Association.)

Senator Stennis chats with Pres. Ronald Reagan in the Oval Office. Senator Stennis was well respected by President Reagan, who made the announcement that the US Navy's seventh Nimitz-class nuclear-powered super carrier would be named after the senator. Stennis was resolute in his support of US military superiority, particularly the US Navy, and is sometimes known as the "father of America's modern Navy." (Courtesy of Kemper County Historical Association.)

Eight

To INFINITY . . .
AND BEYOND
2012–PRESENT

Building on the idea of permitting public viewing of static test firings, officials at Stennis Space Center began to repurpose its iconic Central Control Building, as test stand control centers were proven to remain safe even if located closer to the test stands. Dr. Wernher von Braun, the first director of Marshall Space Flight Center, had a fervent belief in the power of the imaginary arts and education and, at his direction, the lobby of the Central Control Tower always contained informative and entertaining art and exhibits.

The tower was developed and promoted as an on-site tourist destination with the opening of the 1984 World's Fair in nearby New Orleans. At the fair, the space shuttle *Enterprise* was displayed in front of the United States pavilion overlooking the Mississippi River.

When it was fully opened on May 25, 2000, the newly renamed StenniSphere featured 14,000 square feet of instructive displays and exhibits, both indoor and outdoor, from NASA and other resident agencies located at SSC. Bus tours provided, and still provide, a 25-minute narrated tour through SSC's unique acoustical Buffer Zone that surrounds America's largest rocket propulsion test complex.

Further expanding the intersection of education and tourism had been a vision of Leo Seal Jr., president of Hancock Holding Company, and Roy S. Estess, the fourth director of Stennis Space Center. This vision became INFINITY Science Center, sited alongside Interstate 10 where it intersects Mississippi Highway 607, and heralded by the presence of the colossal Saturn V S-1C booster rocket that was destined to power the Apollo 19 mission before the Apollo program ended in 1974.

Simply called INFINITY, the 72,000 square foot facility is designed to engage visitors to explore science, technology, and history using both static and dynamic, indoor and outdoor displays and exhibits. The collection of heroic relics housed within INFINITY will continue to educate and inspire visitors to envision the future of Earth and space exploration to infinity . . . and beyond!

Elementary school students view the SSME with its protective exit cover on display at the Stennis Space Center visitors center in 1993. The center has been visited by more than 30,000 kindergartners through eighth graders each year. (Courtesy of NASA.)

In anticipation of the space shuttle's Return to Flight mission STS-114, StenniSphere featured a special exhibit detailing its importance. The subtitle on the right side of the exhibit reads, "Every launch is a step into the future." More than two years after the February 1, 2003, *Columbia* accident, STS-114 successfully launched on July 26, 2005, and completed its mission on August 9, 2005. (Courtesy of NASA.)

The American Institute of Aeronautics and Astronautics (AIAA) recognized Stennis Space Center as a historical aerospace site on April 10, 2008. From left to right are David Throckmorton, AIAA representative; Mark Hughes, AIAA greater New Orleans chapter chair; Robert D. Cabana, former astronaut and director of SSC; and John Plowden, vice president of Pratt & Whitney Rocketdyne. (Courtesy of NASA.)

Community leaders break ground for the new INFINITY Science Center on November 20, 2008. From left to right are John Smith, Gottfried Construction; Wayne Brown, Mississippi highway commissioner; Fred W. Haise Jr., Apollo astronaut; Gene Goldman, director of SSC; David Hardy, Studio South; Virginia Wagner, representing the family of Leo Seal Jr.; George Schlegel, Hancock Bank president; J.P. Compretta, Mississippi state representative; Charlie Benn, Mississippi Band of Choctaw Indians; and Louisiana state senator A.G. Crowe. (Courtesy of NASA.)

Students from Xavier University Preparatory School in New Orleans watch near-real-time weather drift across the planet's atmosphere, oceans, and land during their visit to StenniSphere in 2009. From left to right are Ashante Snowton, Robriane Larry, Zhane Farbe, and Ebony Johnson. (Courtesy of NASA.)

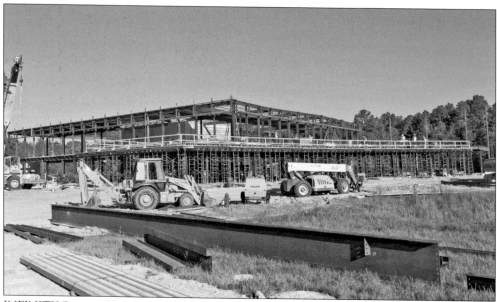

INFINITY Science Center construction continues in 2010 under the direction of Roy Anderson Corp. of Gulfport, Mississippi. The 72,000-square-foot science and education center was spearheaded by INFINITY Science Center Inc., a nonprofit corporation led by George Schloegel, mayor of Gulfport, Mississippi, and Fred W. Haise Jr., Apollo astronaut, in partnership with NASA, the State of Mississippi, and private donors. (Courtesy of NASA.)

Participating in the opening day ribbon-cutting ceremony for INFINITY Science Center on April 11, 2012, are, from left to right, George Schlegel, mayor of Gulfport; Rep. Steven Palazzo (Republican-Mississippi); Sen. Roger Wicker, (Republican-Mississippi); Lauren McKay, granddaughter of Roy S. Estess; Gov. Phil Bryant of Mississippi; Leo Seal IV, grandson of Leo Seal Jr.; Patrick Scheuermann, director of SSC; Sen. Thad Cochran (Republican-Mississippi); David Radzanowski, NASA chief of staff; and Fred W. Haise Jr., Apollo astronaut. (Courtesy of NASA.)

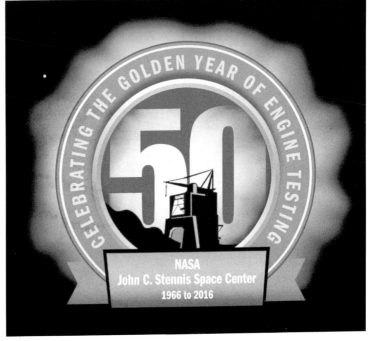

To mark 50 years of static tests, from 1966 to 2016, Stennis Space Center commissioned this illustration to celebrate "the golden year of engine testing." The first test was conducted on the then newly built A-2 Test Stand for a 15-second test firing of a Saturn V second stage prototype, an S-II-C. (Courtesy of NASA.)

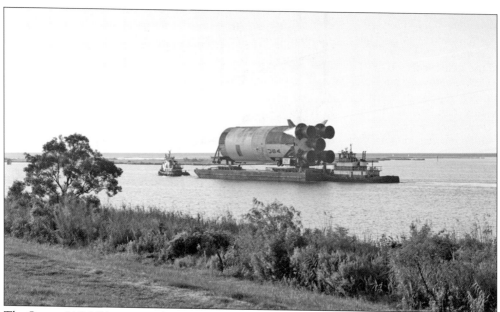

The Saturn V S-1C booster rocket returns to Stennis Space Center from the Michoud Assembly Facility via the same water route it traveled over 45 years ago. The S-1C had been on standby until the end of the Apollo program in 1974, then displayed near the main entrance to Michoud Assembly Facility since 1978, before its final voyage to INFINITY. (Courtesy of Collectspace.)

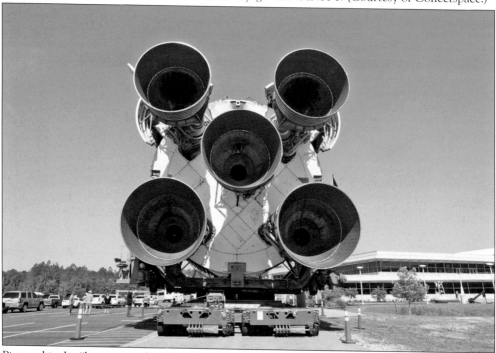

Pictured is the "business end" of five F-1 rocket engines on the S-1C booster rocket the morning after its overnight land journey to INFINITY Science Center on June 16, 2016. The booster will be restored and protected within a dedicated structure as the newest "heroic relic" at INFINITY Science Center. (Author's collection.)

Astronaut and INFINITY board member Fred W. Haise Jr. is interviewed by members of the local media after the welcome ceremony for the "Mighty Apollo 19 Saturn V, first stage to INFINITY Science Center" program. (Author's collection.)

During the Apollo program, 27 Saturn V rocket stages were tested and performed without failure. All main engines used on 135 space shuttle missions were tested at Stennis Space Center. Its newest test stand is capable of long-duration tests on full-scale, gimbaled engines at simulated altitudes up to 100,000 feet. To get to the Moon, one really does have to go through Mississippi. (Author's collection.)

DISCOVER THOUSANDS OF LOCAL HISTORY BOOKS FEATURING MILLIONS OF VINTAGE IMAGES

Arcadia Publishing, the leading local history publisher in the United States, is committed to making history accessible and meaningful through publishing books that celebrate and preserve the heritage of America's people and places.

Find more books like this at
www.arcadiapublishing.com

Search for your hometown history, your old stomping grounds, and even your favorite sports team.